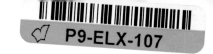

LANDMARKS

The public art program of The University of Texas at Austin

This publication was made possible by the generosity of the Tocker Foundation.

Distributed by Tower Books, an Imprint of the University of Texas Press

LANDMARKS

The public art program of The University of Texas at Austin

2008–2018

EDITED BY Andrée Bober
Catherine Zinser

WITH TEXTS ADAPTED FROM ESSAYS BY

Andrée Bober	Linda Henderson	Veronica Roberts
Kanitra Fletcher	Lynn Herbert	Gwendolyn DuBois Shaw
Valerie Fletcher	Christiane Paul	Robin K. Williams
Lauren Hanson	Nancy Princenthal	

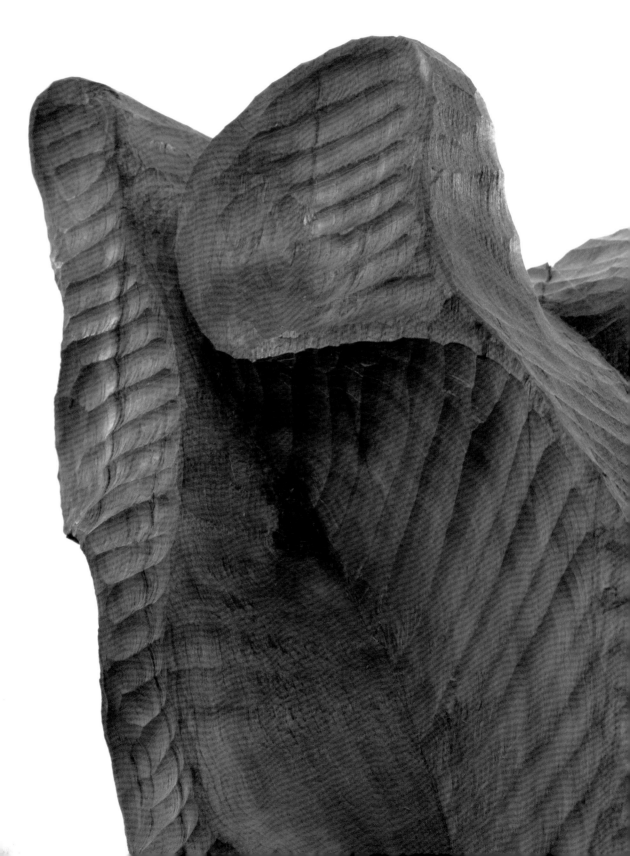

CONTENTS

WELCOME

Crossing the campus in the summer of 2008, no one could foresee how the university's landscape would change over the coming decade. New buildings for student activities, liberal arts, sciences, communications, and engineering were years off, some hardly imagined. The idea of an axial pedestrian mall only existed as a concept vying to become a feasible plan. And who would have guessed that an entire campus would be carved out for a medical school, much less afford space for public art?

The fate of these projects was inconceivable at the time, although support had long been established for capital improvements at the university. To enhance communal spaces, interest coalesced around the idea to introduce public art to Austin's campus. We aimed high in September 2008 with a large group of sculptures on long-term loan from the Metropolitan Museum of Art. With a policy in hand that promised future acquisition funds and a vision to transform the campus landscape, Landmarks was born.

Ten years later, public art at The University of Texas at Austin is a conspicuous presence. Forty-one works of every medium and scale adorn plazas, thoroughfares, gardens, atria, and even a rooftop. Each piece has been carefully considered in relation to its site and as part of the orderly campus master plan. We now enjoy these installations throughout the course of any typical day: between classes and meetings, from windows in neighboring buildings, as meet-up spots for friends and colleagues.

While public art has become a backdrop to our daily routines, it also changes the way we see the world at a time when aesthetic experiences matter more than ever. By virtue of being a fixed presence, it patiently allows new meanings to unfold and our interpretations to evolve. Public art shapes our lives by rewarding our eyes and stimulating our imaginations. Ultimately, it awakens the curiosity that is the beginning of learning and understanding.

By placing public art in the landscape, Landmarks fosters the ideal conditions for thought and growth that sustain a healthy and productive academic environment. Twenty-eight sculptures from the Metropolitan Museum of Art and thirteen subsequent additions are sited across more than four hundred acres, representing significant artistic styles and diverse ideologies. Without cost or impediment, they affirm our fundamental belief that great art can, and should, be free and accessible to all.

On the occasion of Landmarks' tenth birthday, we cheer the university for taking risks and sustaining this vision. We thank our patrons who give generously to support Landmarks' vital education and conservation efforts, and we applaud our many collaborators who make it possible for thousands of people to engage with the collection every day. Above all, we celebrate the artists whose creativity and vision have become inherent in the Longhorn experience.

Andrée Bober
Landmarks Founder and Director

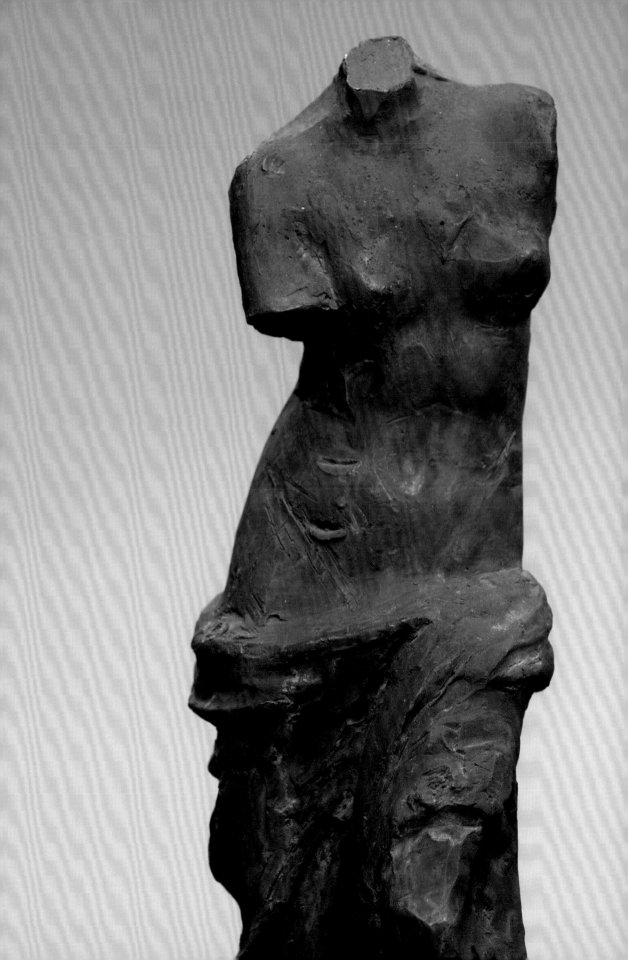

COLLECTION

MAGDALENA ABAKANOWICZ

POLISH, 1930–2017

Profoundly affected by both her solitary childhood and the devastation of World War II, Magdalena Abakanowicz learned to escape loneliness and cruelty by taking refuge in her imagination. During the 1950s, she studied at the Academy of Fine Arts in Warsaw, Poland. Although the official style at that time was socialist realism, Abakanowicz preferred to paint huge gouaches of abstract plants and organic forms. In the 1960s, she began working with natural fibers, creating weavings of flax, hemp, horsehair, sisal, and wool. Unlike many women weavers of the time, Abakanowicz rejected utilitarian concerns, instead creating large reliefs and freestanding forms called *Abakans*: bulbous, flowing, organic, abstract compositions that are hung from a wall or ceiling. With their densely textured surfaces, the works are haunting.

As other artists in Poland turned from socialist realism to abstraction, Abakanowicz became interested in the evocative power of human imagery. For example, her *Garments* series suggests standing figures by means of their empty clothes. From the 1970s through the '90s, she glued burlap sacking and other rough fabrics over metal frames and plaster casts of nude bodies to create figural sculptures that are meditations on aspects of collective life and conformity.

As demand for her sculptures increased, Abakanowicz cast her burlap pieces in bronze editions. Her largest works consist of regimented forms, from as few as four to more than ninety identical figures. Their repetition in rows evokes the dehumanization and anonymity of totalitarian societies. In contrast, *Figure on a Trunk* features a lone human form presented on a stage of sorts, as if for our approval, judgment, or condemnation. The headless body appears to be a hollowed-out husk—a mere shell, emptied of life and energy. The plank on which the figure stands rests on two logs, suggesting a precarious balance. A powerful expression of the human condition, Abakanowicz's sculpture is at once personal and universal, an effigy waiting passively.

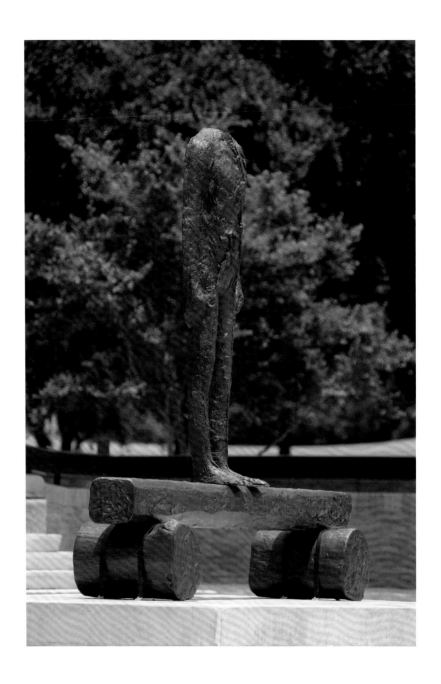

Figure on a Trunk, 2000
Bronze
96 × 103 × 24 inches

Lent by The Metropolitan Museum of Art
Joseph H. Hazen Foundation Purchase Fund,
2000
2000.348a,b

WILLARD BOEPPLE

AMERICAN, BORN 1945

Willard Boepple's birthplace, Bennington, Vermont, became nationally renowned for the art department at its eponymous college. During the 1960s and '70s, the school attracted practitioners and theorists of abstract art, including the leading critic Clement Greenberg (1909–1994) and the British sculptor Anthony Caro (1924–2013). In 1977, after studying on both the East and the West Coasts, Boepple returned to Bennington where he worked closely with Caro as a technical assistant for sculpture. Caro was a master of improvisational composition using sheet metal, and Boepple adapted that technique to his own style. Though he often begins new works with a concept, Boepple states: "Only rarely does the plan survive the making; more often the sculpture takes over, establishing its own rules, its own reality."

In the 1970s, Boepple preferred to use corten steel, a strong yet malleable material that can be cut, bent, and formed to fabricate works with an extraordinary amount of energy and movement. *Eleanor at* 7:15 is a highly articulated, swirling mass of lively, spirited lines with intersecting curves and flat planes. Like many of Boepple's sculptures, this particular piece is modest in scale and smaller than the average person. The artist feels that sculpture should not occupy its own isolated space because proximity allows for a more immediate, intimate exchange.

Aesthetically, this piece adheres to the formalist ideas that drove abstract sculpture during the 1970s, when the context behind a work of art was secondary to purely visual aspects like form and style. Boepple breaks from this tradition by suggesting a narrative within the title. While *Eleanor at* 7:15 resists a figurative interpretation, the title alludes to an intimate moment in the life of the artist. Not meant to be descriptions or explanations, his titles are inspired by places or poetry that evoke a feeling or gesture; here, Boepple envisioned a lively and energetic morning person.

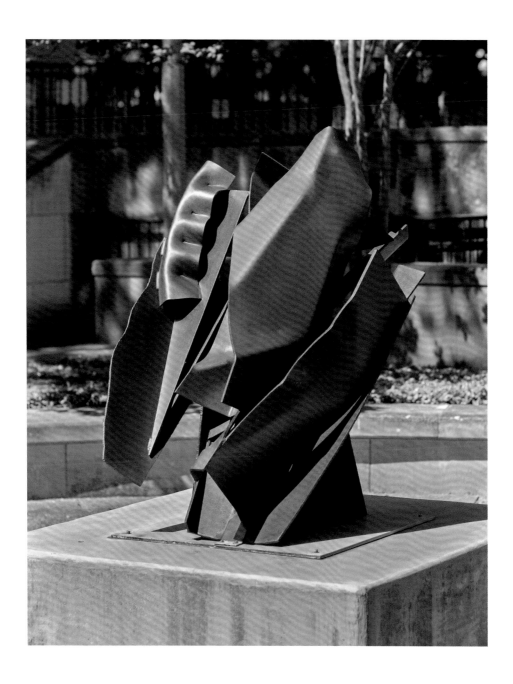

Eleanor at 7:15, 1977
Corten steel
49 × 35 × 45 inches

Lent by The Metropolitan Museum of Art
Anonymous Gift, 1978
1978.567.5

LOUISE BOURGEOIS

AMERICAN, BORN IN FRANCE, 1911–2010

Born in Paris to a family of tapestry craftsmen, Louise Bourgeois moved to New York in 1938. She was initially a painter, but turned to sculpture after World War II and used the roof of her apartment building as a workspace. Although much of her art was motivated by early traumatic events and the resulting psychological turmoil, her sculptures communicate universal concerns, including identity, gender, childhood, sexuality, motherhood, and the continuing power of past and current experiences.

Bourgeois absorbed key ideas from avant-garde art movements, notably surrealism, primitivism, expressionism, and conceptualism, as well as from the study of psychoanalysis and feminist ideology. In the early and mid-1960s, she worked with malleable materials such as plaster and latex to create organic, biomorphic forms that often allude to sexuality, fertility, and growth. Bourgeois first began to sculpt in marble in the late 1960s, selecting her stones from the famous quarries around Carrara, Italy. She liked the transformative process of working from an inert block, stating: "The drilling begins the process by negating the stone.... The cube no longer exists as a pure form for contemplation; it becomes an image. I take it over with my fantasy, my life force. I put it to the use of my unconscious."

A remarkably vigorous artist, Bourgeois carved *Eyes* at the age of seventy-one, shortly after she began to withdraw from social functions in order to concentrate on her art. Despite the hardness of the material, she often arrived at suggestive organic forms, including individual body parts, such as a hand, ear, or leg—or, in this case, eyes. The latter carry many associations, particularly the connotations of "seeing"—literal eyesight, spiritual vision, and windows into the soul. In Bourgeois' sculptures, the eyes usually stare out from deep sockets with unnerving directness. She once indicated that she did not distinguish between "eyes that see the reality of things or...eyes that see your fantasy."

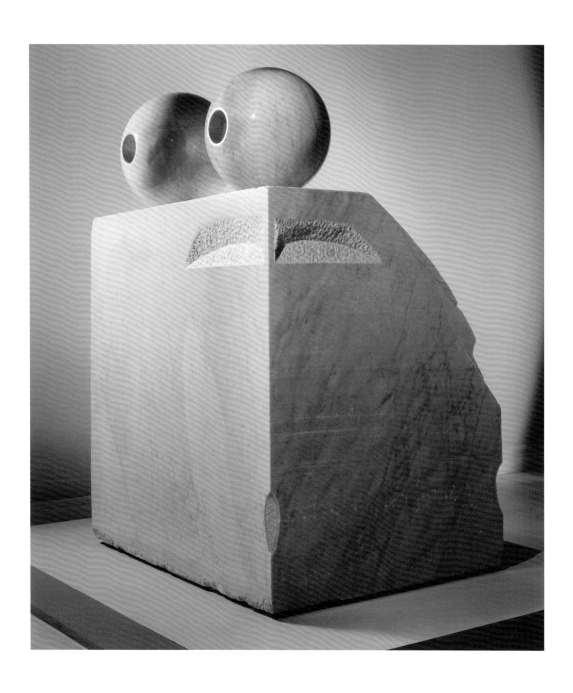

Eyes, 1982
Marble
74 ¾ × 54 × 45 ¾ inches

Lent by The Metropolitan Museum of Art
Anonymous Gift, 1986
1986.397

DEBORAH BUTTERFIELD

AMERICAN, BORN 1949

Born in San Diego, Deborah Butterfield attended the University of California, Davis, with the intent to study veterinary medicine. In the 1960s and '70s, the Davis campus was a lively center for innovative artistic practice and Butterfield eventually turned her attention toward art, receiving an MFA. She moved to a ranch in Montana to raise horses, the inspiration behind her series of sculptures.

Butterfield is an accomplished equestrian, skilled in the formal style known as dressage. She has stated: "I ride and school my own horses and feel that my art relies heavily upon, and often parallels, my continuing dialogue with them." Initially, Butterfield sculpted her horses in a realistic style, using plaster. Later, she turned to the animal's natural environment, composing horses from earthy materials such as mud, sticks, and straw. In 1980, she began to cut, tear, bend, dent, hammer, and weld scrap metal around a support armature to capture a marvelously accurate impression of the anatomy of living horses. *Vermillion* is life-sized; although rendered abstractly, it conveys Butterfield's expert knowledge of equine anatomy.

Horses have been a motif in art since antiquity; however, unlike most historical examples, Butterfield's horses do not support a human rider—no victorious king or general, no chaps-clad cowboy, not even a diminutive jockey has dominion in her compositions. Butterfield also eschews traditional depictions of racing or rearing horses, which typically symbolize fierce competitiveness, rebellious independence, and aggression. Her horses stand, graze, muse, sniff the breeze, or occasionally rest on the ground, as if at home in their own pastures. This decidedly subdued approach reveals something of the artist's identity: "I first used the horse image as a metaphorical substitute for myself—it was a way of doing a self-portrait, one step removed from the specificity of [me]."

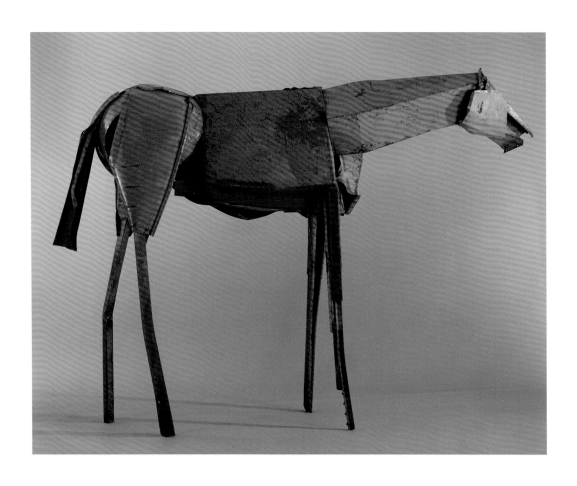

Vermillion, 1989
Painted and welded steel
75 × 108 × 25 inches

Lent by The Metropolitan Museum of Art
Gift of Agnes Bourne, 1991
1991.424

ANTHONY CARO

BRITISH, 1924–2013

Before he was drafted into the British Navy during World War II, Anthony Caro studied engineering at Cambridge University. Instead of returning to Cambridge after the war, he enrolled at the Royal Academy in London to study sculpture. Caro went on to work as a studio assistant to Henry Moore (1898–1986), who was then the most important and renowned sculptor in Great Britain.

In the late 1950s, Caro sculpted figures, but his first extended visit to the United States in 1959 prompted a radically new direction in his work. He met the powerful modernist critic Clement Greenberg (1909–1994) and several notable abstract artists, particularly the sculptor David Smith (1906–1965). Upon his return to London, Caro created his first welded and painted steel works. During the 1970s, however, he found himself becoming "too comfortable" with color, and he stopped using paint in order to focus on the composition of forms and space, elements that Greenberg also emphasized. Thereafter, he preferred raw corten steel that he encouraged to weather naturally outdoors.

Despite the weight and unwieldiness of industrially produced steel, Caro composed his works spontaneously, without preliminary drawings or models. In this sense, his sculptures are like three-dimensional equivalents of gestural drawings. Caro used sheets of steel as if they were sheets of paper: cutting, tearing, and folding them like large-scale, sculptural collages.

In November 1972, and again in May and November 1973, Caro worked at the Rigamonte factory in Veduggio, Italy. He used steel remnants from the factory's scrapyard to assemble fourteen sculptures (as David Smith had famously done at a factory in Volta, Italy, in 1959). Despite the titular reference to the place at which it was made and the fact that the form resembles a landscape, *Veduggio Glimpse* is an abstract work, intended to be appreciated purely for its visual qualities.

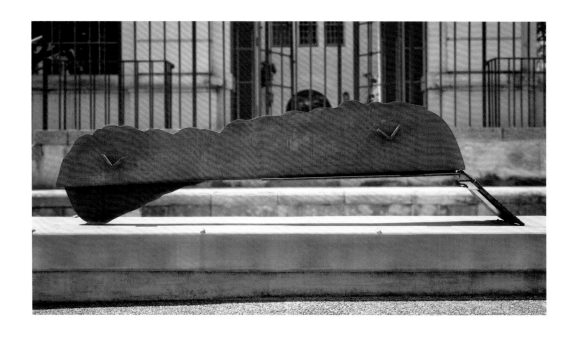

Veduggio Glimpse, 1972–1973
Steel
30 × 113 ½ × 18 inches

Lent by The Metropolitan Museum of Art
Anonymous Gift, 1986
1986.440

MICHAEL RAY CHARLES

AMERICAN, BORN 1967

Michael Ray Charles was born in Lafayette, Louisiana, in 1967, when the nonviolent civil rights movement was giving way to riotous social and cultural upheaval. Like artists Kara Walker (b. 1969) and Fred Wilson (b. 1954), Charles explores African and African American oppression and prejudice through his practice. He is best known for work that appropriates derogatory images in order to disparage racist stereotypes. For *(Forever Free) Ideas, Languages and Conversations*, Charles takes a more metaphorical approach, explaining, "Conceptual and representational applications of power throughout visual cultures past and present have been among my most significant triggers of creative inspiration."

(Forever Free) Ideas, Languages and Conversations is suspended in the atrium of the Gordon-White Building, home to centers that are committed to studying the history and experience of minority cultures. Charles selected the location because it joins a classic 1952 university building to a newly constructed addition used by students and scholars of the historically marginalized. In designing the atrium's interior, he preserved architectural ornaments from the original building and added rough, exposed surfaces to the atrium, creating a meaningful segue into the polished departmental offices. The result is both sculpture and site—a symbolic transition between the inherited establishment and a future that explores new ways of thinking and being.

Charles' sculpture is made from wooden crutches assembled in groups to create star-shaped wheels. The individual parts form a common mass in an energetic composition. When imagining the project, Charles was partly inspired by the activity of scholars who study minority cultures and the challenges they have faced in academic institutions. *(Forever Free) Ideas, Languages and Conversations*, now the centerpiece of a thriving enterprise that champions multiculturalism and diversity, is emblematic of institutional progress and transformation. By claiming the wounds of the past and acknowledging the support needed to heal, it recognizes all who have suffered inequality and carries the promise of future growth and hope.

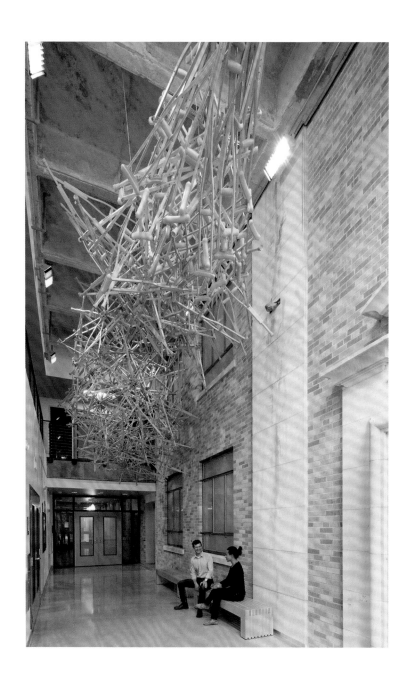

(Forever Free) Ideas, Languages and Conversations, 2015
Wooden crutches, steel armatures, and steel cables
155 × 412 × 125 inches

Commission, Landmarks, The University of Texas at Austin, 2015

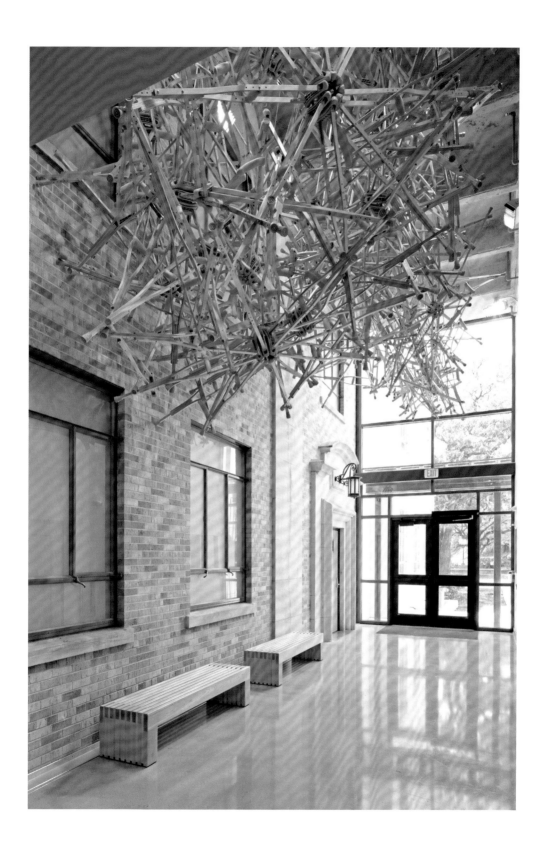

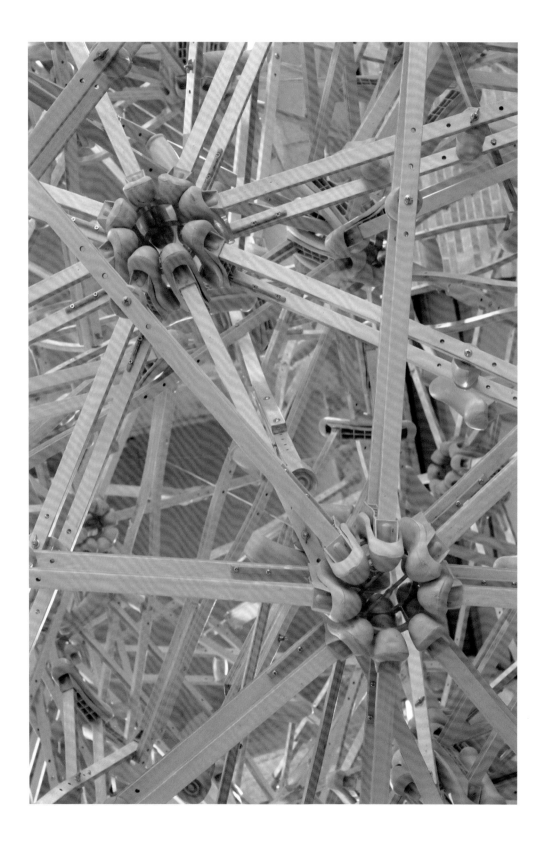

KOREN DER HAROOTIAN

AMERICAN, BORN IN ARMENIA, 1909–1992

In 1915 Koren Der Harootian fled Armenia with his mother and siblings to escape the persecution and genocide of the ruling Turks. They first went to Russia and eventually immigrated to the United States, settling in an Armenian community in Worcester, Massachusetts. Der Harootian studied painting at the school of the local museum and independently developed his skill with watercolor landscapes. In the 1930s, he moved to Jamaica to paint. There, he befriended sculptor Edna Manley (1900–1987), whose primitive, eroticizing style had a profound impact on his work. Eventually, Der Harootian began to carve figural sculptures in wood and stone using handmade tools. Together, Manley and Der Harootian stimulated a new genre steeped in Jamaican culture.

The story of Prometheus had great resonance during this time. According to ancient Greek mythology, Prometheus defied Zeus by giving humans fire, launching a new era of progress, learning, and culture. Angered, Zeus punished Prometheus by chaining him to a high mountain where each day an eagle would eat his liver. At night, his body would heal so that the punishment could begin again. Finally, after thirteen human generations, the half-divine hero Hercules liberated Prometheus.

In *Prometheus and Vulture*, Der Harootian substitutes a vulture for the eagle to demonstrate the demoralization of society as a result of World War II. Here, the hero strains against his chains, reeling in pain, as the vulture plunges for his daily attack. Prometheus is understood to be the god of foresight; knowing that he would eventually be released, he endured hundreds of years of torment in order to bring critical knowledge to humans. Der Harootian favored such classical and religious subjects as metaphors for the fears, violence, and conflicts of World War II. Many people in Europe, Africa, Asia, and America suffered bitterly, but like Prometheus, they believed their struggle would advance mankind and that they would eventually be released from oppression and torment.

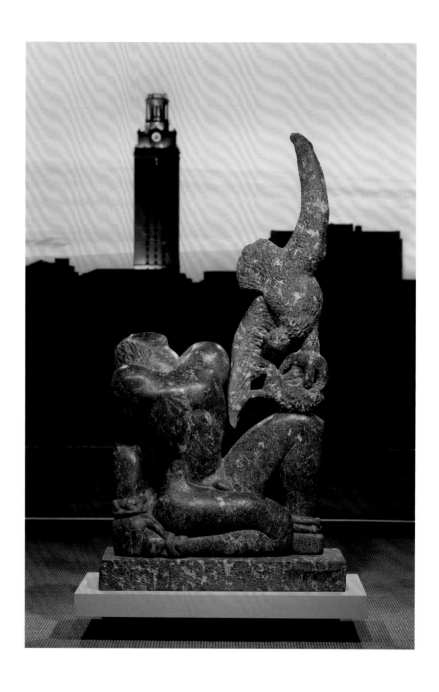

Prometheus and Vulture, 1948
Marble
62 ½ × 33 ¾ × 15 ½ inches

Lent by The Metropolitan Museum of Art
Gift of Haik Kavookjian, 1948
48.142a–c

JIM DINE

AMERICAN, BORN 1935

Born and raised in Ohio, Jim Dine moved to New York in 1958 and became established in the art world with theatrical Happenings performed in chaotic, artist-built environments. He began experimenting with assemblages and representing common objects in his paintings, drawings, and prints, ultimately becoming one of the pioneers of Pop art. Countering the previous generation's elevated aspirations for abstract expressionism, Pop artists are known for choosing ordinary subjects as emblems of consumer society and "lowbrow" popular culture, often presented with ironic detachment. Dine painted numerous images of bathrobes, neckties, hearts, and tools; some of his compositions incorporated physical objects, a decision that marked the beginning of his interest in sculpture.

In the late 1960s, Dine integrated motifs with increasing personal significance. His composition of various objects on a table in *History of Black Bronze I* may refer to Alberto Giacometti's (1901–1966) surrealist *Table* (1933), which features elements that refer to Giacometti's other sculptures. Dine updates that idea to reflect the 1980s taste for art historical appropriation. The items range from icons of classical art to the ordinary tools that became symbolic subjects for the artist, a resonance from his youth working in his family's hardware store.

Dine's choice of title and material make further reference to the history of art. Ancient Greeks and Romans forged an alloy called black bronze, or *hepatizon*, from copper and small amounts of silver and gold. It was valued over other types of bronze and was a popular material for sculpture. This nod to antiquity, along with the uniform size of the items on the table, elevates the mundane hammer to the level of appreciation warranted by the Great Sphinx of Giza, the *Venus de Milo*, and modern sculptures by Giacometti and Auguste Rodin (1840–1917).

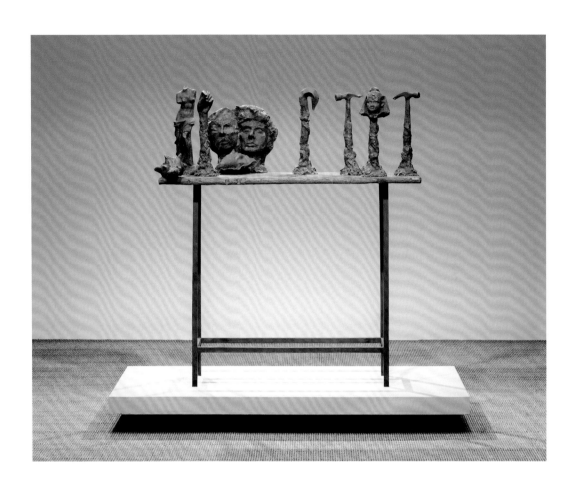

History of Black Bronze I, 1983
Bronze
53 ¼ × 48 × 20 inches

Lent by The Metropolitan Museum of Art
Gift of Industrial Petro-Chemicals, Inc., 1987
1987.363

MARK DI SUVERO

AMERICAN, BORN IN CHINA, 1933

Mark di Suvero is one of the most important sculptors of his generation. As a student, he was deeply engaged in studying and writing poetry and listening to music, from Bach to jazz. Once he began to make sculpture, di Suvero found outlets for his interests in other fields, including architecture, mathematics, science, engineering, and languages.

Di Suvero's work is grounded in abstract expressionism, which emphasizes the direct expression of emotion through line and color. He was energized as a young artist by the spaces of New York City, especially those being torn down for "urban renewal." From the refuse, he pioneered a new form of sculpture in which wooden beams chained together in outward-leaning constructions declared the physical forces that held them in check. The works engage space in an unprecedented manner, a central focus throughout di Suvero's career. He began to build large-scale sculptures with a crane in 1967, using steel I-beams and other industrial materials. Learning to use a crane offered di Suvero a new mode of working, but the process of composing the sculpture remained at the core of his artistic practice.

The heroic sculpture *Clock Knot* exemplifies the power of art to transform public realms. Walking around and under the work produces constantly changing views. The crossed I-beams and circular "knotted" center of *Clock Knot* suggest a giant clock face with a horizontal "hand" extending to the left. But as one moves around the sculpture, what had been read as a vertical beam shows itself to be one leg of an inverted V-form. Is it a clock or not/knot? *Clock Knot* is a work of poetry and power. As one passes through its space looking at the sky and feeling the exuberant lift of the sculpture, the imaginations plays with its visual and verbal suggestions.

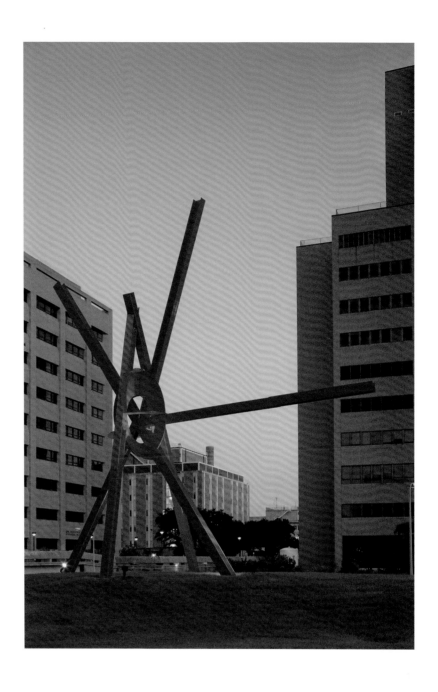

Clock Knot, 2007
Painted steel
498 × 260 × 420 inches

Purchase, Landmarks, The University of Texas
at Austin, 2013

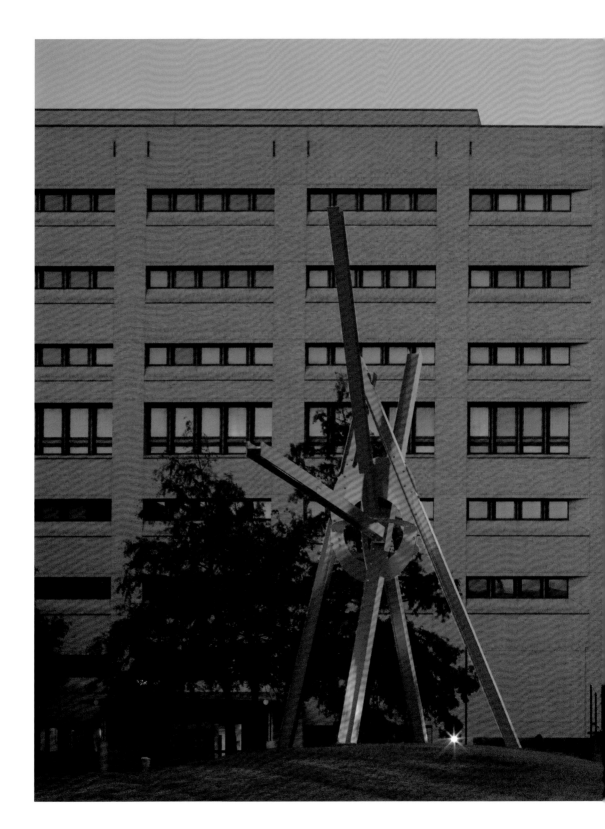

WALTER DUSENBERY

AMERICAN, BORN 1939

Born in Alameda, California, Walter Dusenbery has an artistic lineage that includes an impressive group of masters. After studying at San Francisco Art Institute and the California College of Arts and Crafts, Dusenbery assisted Japanese American sculptor Isamu Noguchi (1904–1988), who had studied under modernist master Constantin Brancusi (1876–1957), who, in turn, had worked in Auguste Rodin's (1840–1917) Parisian workshop.

Dusenbery preferred the tradition of direct carving to the popular method of welding metal sculpture that was prevalent during the 1950s and '60s. But his larger forms, on the scale of *Pedogna*, required considerable geometric calculation and planning; thus, they could not be improvised. Many direct-carve sculptors feel a strong physical and psychic link with the natural materials they use, a sensitivity that Dusenbury shared with Noguchi. However, whereas Noguchi worked in fine marbles, variegated granites, and rough basalt, Dusenbery favored travertine, a porous carbonate stone that is easily cut. In its pure state, travertine is white, but mineral or biological impurities can infuse the stone with various hues, such as the reddish color seen in *Pedogna*. With a footprint in the shape of a horse's hoof, the sculpture contrasts two kinds of articulated surfaces: a smooth, round, and bell-shaped base with a rusticated side.

The title of this sculpture refers to the secluded Pedogna Valley in Northern Italy, which can only be reached by foot. The sculpture celebrates the wonders of the natural environment, with striations formed over hundreds of millions of years. Interestingly, the artist chose not to arrange *Pedogna's* segments in geological order, perhaps a play on the question of time. Dusenbery often carves vertical, totemic, abstract sculptures from a single massive stone. These monoliths intentionally convey an ancient aura, evoking sources like the mysterious dolmens of Stonehenge and the lingams of Shiva in India.

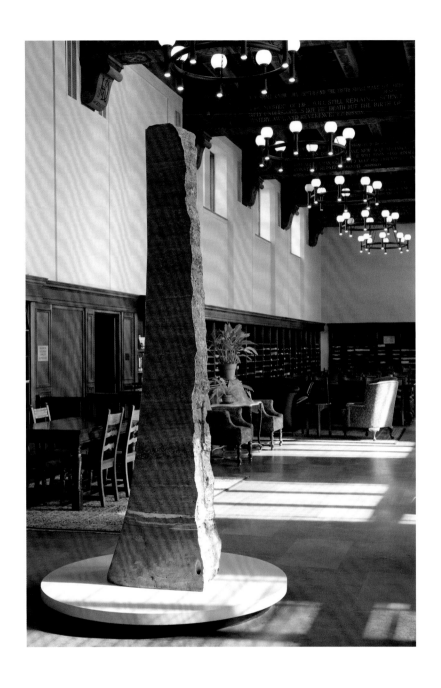

Pedogna, 1977
Travertine marble
102 ½ × 25 ½ × 21 ½ inches

Lent by The Metropolitan Museum of Art
Gift of Doris and Jack Weintraub, 1979
1979.300a–h

DAVID ELLIS

AMERICAN, BORN 1971

Multimedia artist David Ellis grew up immersed in various musical styles, from jazz to hip-hop. Though he never learned to read music or play it, he employs various elements of music-making in his work. His explorations of movement, change, and rhythm effectively unite his ability to create striking imagery with his passion for musical expression.

The collaborative and improvisational nature of music influenced a series of painting sessions that Ellis undertook with a group of artists he founded called the Barnstormers in the early 2000s. Captured with time-lapse video, the paintings on vertical surfaces evolved into a style that Ellis calls "motion paintings." For *Animal*, he positioned a time-lapse camera overhead to photograph his painting process every few seconds. He then compiled the images into a stop-motion video. Similar to a hip-hop track, Ellis' motion paintings are an assortment of samples, breaks, and disparate moments, all of which combine to create a rhythmic flow of artistic improvisation.

Animal is the visual record of Ellis' six-week residency at The University of Texas at Austin. Produced in collaboration with cinematographer Chris Keohane and composed of more than 75,000 still images, the video is inspired by personal conversations and the local environment of Austin. *Animal* showcases the delights and details of the creative forces of nature that often go unnoticed.

The animation features a kaleidoscope of spectacular creatures, landscapes, and abstractions interspersed with dramatic splashes of paint. Its soundtrack, composed by longtime collaborator Roberto Lange (b. 1980), combines a range of unexpected elements that complement the mercurial nature of Ellis' practice. *Animal* shifts between moments of freedom, discovery, and surprise that extend from Ellis' continuous search to represent the universality of art through the rhythms and movement of life.

Stills from *Animal*, 2010
9 min., 39 sec., color, sound, Blu-ray disc

Commission, Landmarks, The University of
Texas at Austin, 2010

RAOUL HAGUE

AMERICAN, BORN IN TURKEY, 1904–1993

Born to Armenian parents in Istanbul, Turkey, in 1904, Raoul Hague came to the United States to further his education, enrolling in Iowa State College in 1921. At that time, he changed his name from Heukelekian to Hague. After a year in Iowa, he left to attend the School of the Art Institute of Chicago.

In 1925, Hague moved to New York City and two years later, while studying under William Zorach (1887–1966), he began to sculpt in stone. One of the first artists to employ direct carving, Zorach preferred that method to modeling in plaster or clay for casting into bronze. In an era of increasing mechanization, carving with traditional hand tools reasserted the importance of natural materials and handicraft. In the 1940s, Hague settled in Woodstock, north of New York City, where he lived the rest of his life. Shifting away from stone, he carved almost exclusively in local wood, retaining the natural shape of the tree in his finished compositions. Hague's respect for the inherent textures, colors, and shapes of wood remained the aesthetic focus of his entire career.

During the 1960s, Hague's sculptures became larger and more abstract. The massive flowing forms were considered by some admirers and critics to be a three-dimensional counterpart of the broad, sweeping brushstrokes characteristic of abstract expressionist paintings. The four tilting verticals in *Big Indian Mountain* can indeed be compared to paintings by Franz Kline (1910–1962)—a central figure of the abstract expressionist movement in New York—but their origins lie in the branching of a large walnut tree trunk. By preserving the visual evidence of the wood's structure, Hague alludes to the power of growth in nature. His inherent respect for the physical contours of the found trunk may also comment indirectly on the massive clear-cutting of American forests in the 1960s.

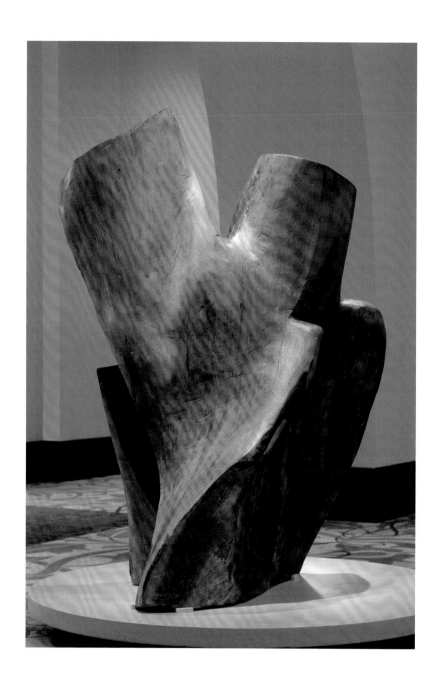

Big Indian Mountain, 1965–1966
Black walnut
64 × 45 × 49 inches

Lent by The Metropolitan Museum of Art
Louis V. Bell Fund, 1974
1974.6

ANN HAMILTON

AMERICAN, BORN 1956

O N E E V E R Y O N E is framed by the idea that human touch is the most essential means of contact and a fundamental expression of physical care. Commissioned for the Dell Medical School, the work began as a campaign to photograph more than five hundred members of the Austin community and welcomed any person who had ever received or provided healthcare—*everyone*.

With more than twenty-one thousand images, *O N E E V E R Y O N E* expanded to assume multiple forms: porcelain enamel panels that line the corridors of medical school buildings; a publication featuring contributions by poets, philosophers, scientists, and essayists; a book circulated freely that holds portraits of each participant; a website where photographs may be downloaded; and an exhibition at the Visual Arts Center.

The relationship between photographer, camera, and subject is central to Hamilton's concept and follows naturally from her early photographic experiments that used unconventional methods to capture images. To create *O N E E V E R Y O N E*, participants stood behind a semi-transparent sheet that focused only the points of the body touching the material. The subjects, directed by the artist to turn in various ways, could not see through the membrane and relied on the sound of her voice for guidance. Hamilton describes this condition as analogous to the experience of medical care: the sitters, like the patients, offer themselves for physical examination. In doing so, they accept vulnerability and extend trust.

Her resulting portraits share an ethereal quality and capture expressions of intense inward focus. Faces are elusive, obscured by the material that only renders sharply the contact of touch. By trading literal appearance for a less tangible resemblance, a different kind of portrait emerges—one that is at once intimate and ineffable. *O N E E V E R Y O N E* extends the broad and most consequential themes of Hamilton's art: the primacy of sense experience; the systematic representation of the individual; the commonalities of people in all their manifestations; and the power and poignancy of communal exchange.

PORTRAITS ON THE FOLLOWING PAGES:

50
Melody · Erin Huey · Angelica Saungeun · Ava

51
Charles · Joshua Ethan · Porscha John · Sara

53
Yael Lawrence

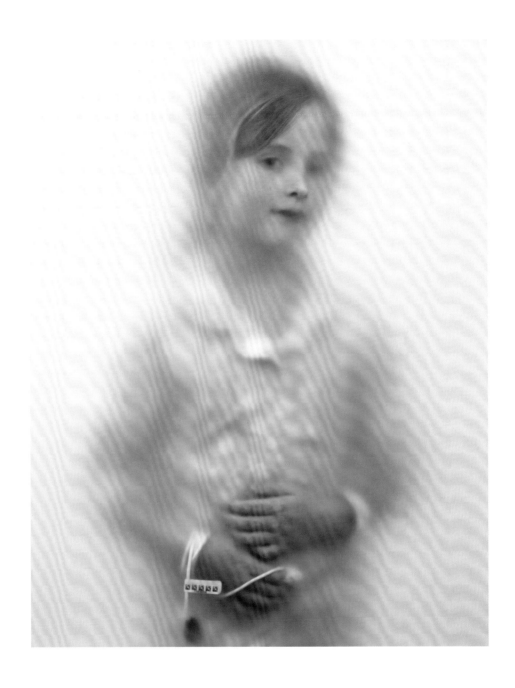

ONEEVERYONE · Zoë, 2017
Porcelain enamel
Dimensions variable

Commission, Landmarks, The University of
Texas at Austin, 2017

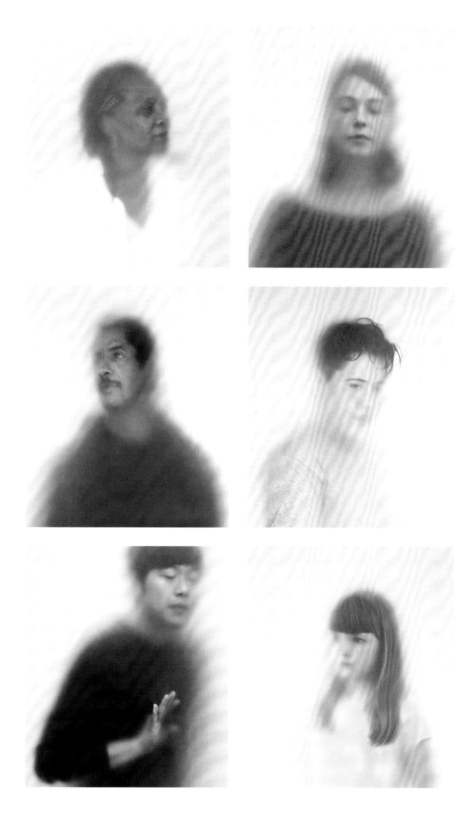

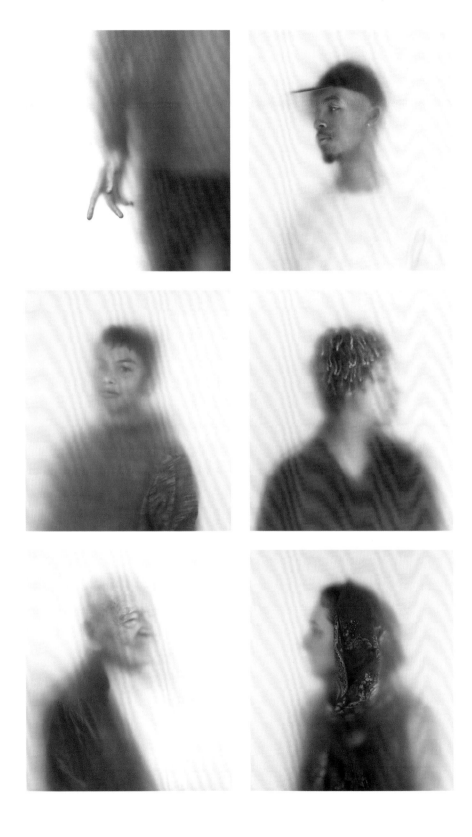

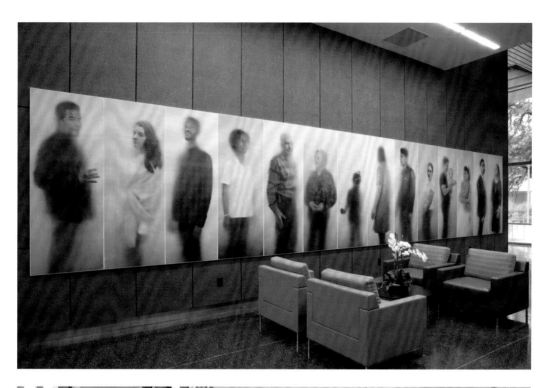

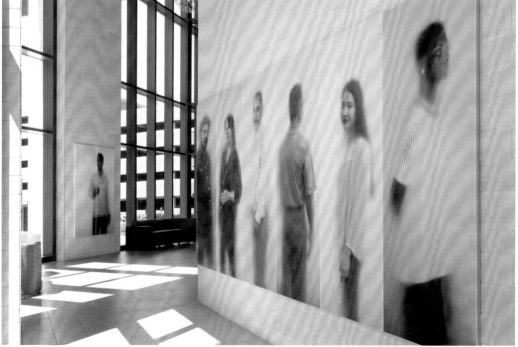

JUAN HAMILTON

AMERICAN, BORN 1945

Juan Hamilton moved to New York from South America at the age of fifteen. He graduated from Hastings College in Nebraska, then earned his MFA in pottery from Claremont College in California. Hamilton's outlook on life and art were profoundly affected by his introduction to Zen Buddhism during a trip to Japan in 1970, after which the philosophy became central to his art. He hoped the abstract forms in his work—which were never merely decorative—would generate an inner peace in viewers.

Hamilton's life and art took a new direction in 1973, when he became the primary assistant to the renowned modernist painter Georgia O'Keeffe (1887-1986). Her rigorously simplified yet sensuous forms in painting influenced his aesthetic sensibility. But as he moved from pottery to sculpture, Hamilton went further into pure abstraction, sculpting smooth, curving forms in the tradition of the pioneering European modernists like Constantin Brancusi (1876-1957) and Jean Arp (1886-1966). However, unlike those earlier abstractionists, who derived their forms from sources in nature, Hamilton conceived his works as projections of his innermost state of mind: "They come from inside me. I feel them three-dimensionally in the center of my chest."

Curve and Shadow, No. 2 was made during the time in which Hamilton was working for O'Keeffe. He emphasized the integral importance of the transient shadow's curve by giving it equal status in the title. The sculpture stretches from ground to ground; when exhibited in sunlight, its shadow appears underneath in a reciprocal curve. The changing light alters the shadow—making visible the passage of time. As part of Hamilton's intention to create art relevant to spiritual contemplation, *Curve and Shadow, No.* 2 has a superbly refined surface. For him, the visual purity of the form expresses an inner clarity of spirit.

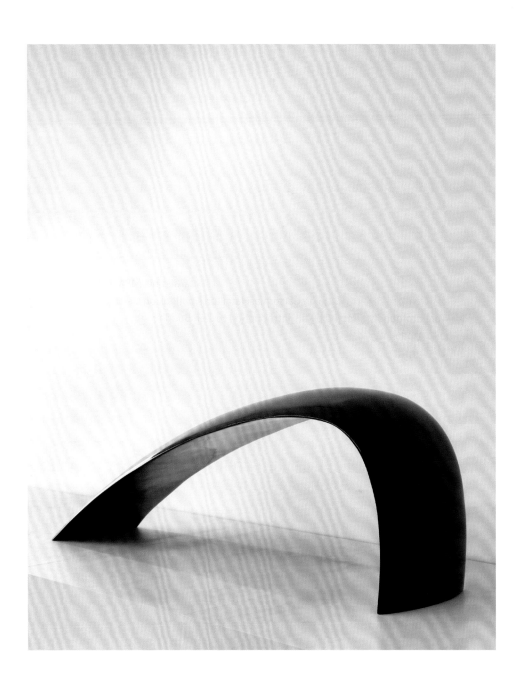

Curve and Shadow, No. 2, 1983
Bronze
32 × 96 × 24 inches

Lent by The Metropolitan Museum of Art
Anonymous Gift, 1983
1983.540.1

DAVID HARE

AMERICAN, 1917–1992

After earning degrees in chemistry and biology, David Hare began experimenting with photography, using his previous education to explore techniques that manipulate and distort images. In the early 1940s, Hare befriended several European surrealists who had moved to New York seeking refuge from the ravages of World War II. He adopted many of their ideas, including an enthusiasm for the concepts of Freudian psychoanalysis. In 1942, after meeting the self-proclaimed leader of the surrealist movement, André Breton (1896–1966), Hare acknowledged the importance of free association in the creation of art.

Beginning in 1944, Hare began to sculpt, seeking to create works that blend elements from reality with different "relations of memory and association." As the surrealist movement faded in the 1950s, he adapted his style to a more abstract mode in keeping with the emergence of formalist aesthetics, but he retained the surrealists' principle of suggesting a subject and relying on viewers to draw meaning from the work with freely associated insights.

Hare worked in a variety of media before settling on metal, at a time when other sculptors used the material for its symbolic reference to the industrial Machine Age. For his part, he preferred the medium for its malleability and durability, while gravitating toward fragile, slender forms with spindly accents that were supported structurally in bronze.

The Swan's Dream of Leda refers to the classical Greek myth in which Zeus desired a beautiful human woman named Leda. In order to seduce her, he tricked her by appearing in the guise of a swan. Little more than a paean to male lust, the tale enabled popular portrayals of sensuous female nudes in Renaissance and post-Renaissance art. To an artist steeped in surrealism and Freudian analysis, the subject offered rich possibilities for sexual innuendo. Yet, rather than the literal motifs portrayed by many male surrealists, Hare's forms, such as the swan's flapping wings, are more suggestive.

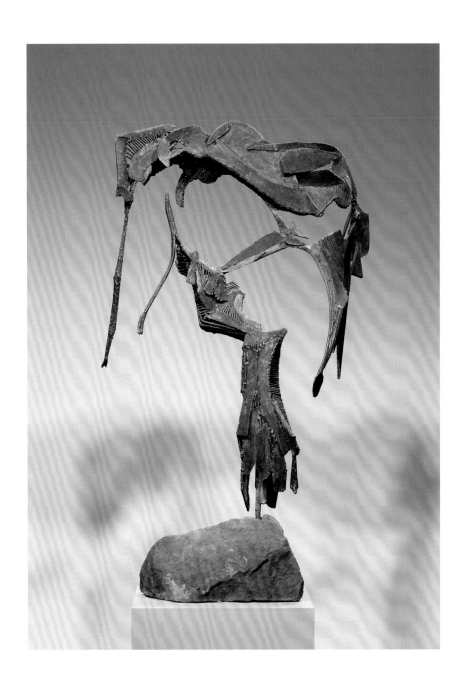

The Swan's Dream of Leda, 1962
Bronze with stone base
53 ¾ × 33 ½ × 9 ¾ inches

Lent by The Metropolitan Museum of Art
Gift of the artist, 1963
63.83a,b

HANS HOKANSON

AMERICAN, BORN IN SWEDEN, 1925–1997

A native of Malmö, Sweden, Hans Hokanson came to the United States in 1951. While aspiring to be a painter, he supported himself with carpentry work and became a master cabinetmaker and furniture designer. His first wood sculptures were assemblages of abstract components, and by the 1960s, he was carving directly in solid wood.

Profoundly inspired by the philosophy and aesthetics of Zen Buddhism, Hokanson's carvings engaged his entire body and mind. However, he did not practice the spontaneity that is often associated with Zen mastery. Instead, he preferred to make detailed preliminary drawings before starting a new sculpture—the antithesis of Anthony Caro (1924–2013), who improvised directly with heavy steel.

Hokanson's interest in abstract forms was largely inspired by his work as an assistant in the Museum of Primitive Art in New York. There he studied the well-known wood artifacts from Africa and lesser-known carvings from Indonesia, especially Papua New Guinea. These complex curving forms reverberate through some of Hokanson's formalist abstractions.

During the 1970s, Hokanson began making sculptures from massive tree trunks. "I am influenced by the volume … of the wood…. The wood itself … encourages me, speaks back to me. I am in direct confrontation with the surface," he said. Some of his remarkable compositions consist of enormous freestanding spirals that took considerable skill and many months to hew from the solid wood.

Source was carved from the trunk of an exceptionally large cherry tree. Its silhouette, surface, and title allude to organic movement and growth. With undulating upper forms that seem to reach for the sky, its patterns suggest a waterfall or brook (the term "source" in French means a natural spring). The chiseled texture echoes nature: the flicker of sunlight on water, the ridges of sand at low tide, or leaves fluttering in the breeze.

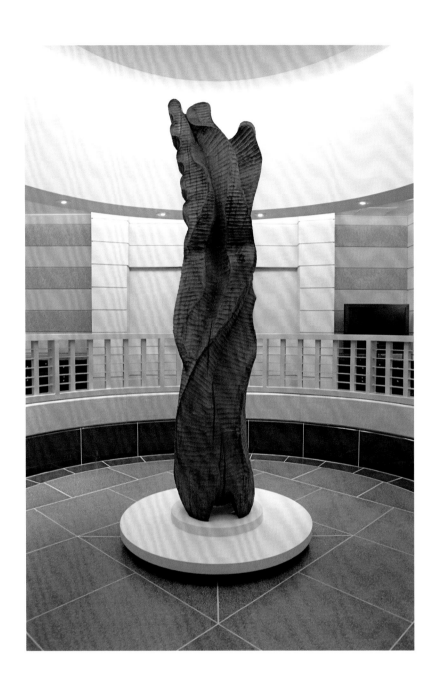

Source, 1977
Cherry
98 × 20 × 25 inches

Lent by The Metropolitan Museum of Art
Purchase, Friends of the Artist Gifts, 1978
1978.87

BRYAN HUNT

AMERICAN, BORN 1947

Born in Indiana, Bryan Hunt attended the University of South Florida with the intention of becoming an architect, but was quickly drawn to painting. He moved to Los Angeles to attend the Otis Art Institute, where he obtained his BFA in 1971. Hunt's sculptures in the early 1970s were architectural models of famous landmark structures, such as the Hoover Dam and the Empire State Building. Later, he began to explore modern philosophy and literary theory, admiring the purist aesthetics of Barnett Newman (1905–1970) and the newly established minimalists. His work soon took a new direction; rather than adopting pure abstraction, he applied the clarity of minimalist ideals to his representations of objects and places.

In 1979–1980, fascinated by topography, he modeled series of amorphous sculptures titled *Lakes* and *Waterfalls*. The bronze surfaces are highly articulated to convey a sense of energy—a stylistic tradition established by Auguste Rodin (1840–1917) in the 1880s and revitalized by Alberto Giacometti (1901–1966) in the 1940s and '50s. Hunt was particularly inspired by Willem de Kooning's (1904–1997) expressionistic sculptures of the 1970s.

Throughout the 1980s, Hunt retained this highly modeled surface texture while focusing on motifs from classical Greek art and culture. His *Maenad* sculptures, although abstract, evoke the swirling draperies of Hellenistic works. *Amphora* refers to a tall, slender, two-handled vessel, usually made of clay and used to store food and drink, especially wine. However, rather than a sturdy, practical container, Hunt's *Amphora* is flat and visually unstable; it serves primarily as a pretext for modeling forms and creating expressive surfaces. Viewers are free to solely enjoy the visual, but may also appreciate the sculpture's statement about the diminished value of most classical culture today.

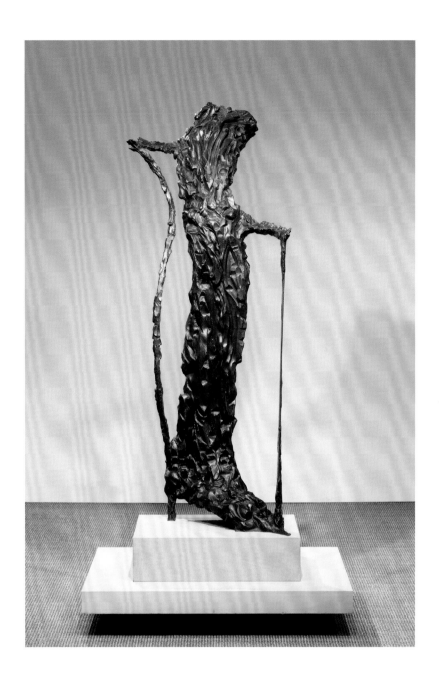

Amphora, 1982
Bronze
97 ¾ × 30 × 25 inches

Lent by The Metropolitan Museum of Art Purchase, Louis and Bessie
Adler Foundation, Inc. Gift (Seymour M. Klein, President), 1983
1983.88a,b

FREDERICK KIESLER

AMERICAN, BORN IN AUSTRIA, 1890–1965

Frederick Kiesler trained as an architect before turning to sculpture and design. Like many other European modernists in the 1920s, he was a utopian idealist. Kiesler first gained recognition in 1925 at the International Exposition of Decorative Arts in Paris, where he exhibited a large gridlike structure titled *City in Space*. Its straight lines and flat planes joined at right angles embodied the utopian belief that simple geometric forms in art would help facilitate a more rational and egalitarian society.

Within a few years, however, Kiesler abandoned that approach in favor of curving biomorphic forms. The new surrealist movement rejected rationality and regularity in art and favored forms inspired by sources in nature—plants, animals, microscopic organisms, water, clouds, and rocks.

Winged Victory alludes to the famous Greek statue *Winged Victory of Samothrace* from the second century BCE, now in the Louvre. Created to commemorate a military conquest, the white marble female figure strides forward. Her body, widespread wings, and peplos are animated as if in an invigorating breeze. Kiesler reinterpreted that iconic monument to victory: here, the figure has vanished, leaving only its darkened wings collapsing.

The motif of wings falling to earth evokes other sources as well, such as the biblical downfall of angels immortalized in John Milton's epic poem *Paradise Lost* or the Greek myth of Icarus. In the years after World War II, the myth of Icarus especially appealed to some artists and writers. On manmade wings of feathers and wax, Icarus became the first human to fly. But he flew too close to the sun, the wax melted, and he plummeted to his death—much as the utopian aspirations of Kiesler's generation had been crushed by war. *Winged Victory* offers a poignant visual metaphor for the collapse of the ideas and ideals of Western civilization as well as the destruction often inherent in victory.

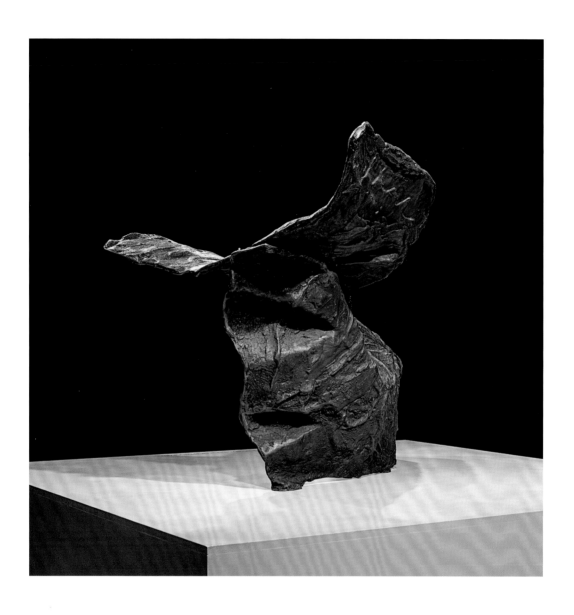

Winged Victory, circa 1951
Bronze
30 × 28 × 24 ½ inches

Lent by The Metropolitan Museum of Art
Gift of Salander-O'Reilly Galleries, Inc., 1983
1983.200

SOL LEWITT

AMERICAN, 1928–2007

During the 1960s, Sol LeWitt helped formulate the tenets of a burgeoning conceptual art movement by arguing that the concept behind a work of art was more important than its execution. His instruction-based conceptual practice proposed a very different model of artistic authorship, one that was defined by an artist's ideas, not by the personal touch or mark of the artist's hand. In providing a set of instructions for others to carry out, LeWitt likened his role as an artist to that of an architect or composer. He drafted compositions that could exist in more than one place at a time and could have infinite interpretations, in the same way that different musicians can play a sonata by Bach.

Although LeWitt is best known for the numerous wall drawings he made during his lifetime, when asked once about inventing the medium, the artist drolly replied: "I think the cavemen came first." Unlike his predecessors, however, LeWitt made wall drawings that do not exist as permanent objects; rather each is a diagram and a set of instructions.

During the 1980s, LeWitt produced many jewel-toned, ink-wash wall drawings like *Wall Drawing #520*, dramatically expanding his repertoire from the pencil versions that predominated in the first decade of his career. In this work—one of the few that the artist conceived for three walls—cubes float across the surface in rich, variegated colors. The palette and slight depth of the geometric figures attest to the artist's interest in Italian Renaissance frescoes, one that was spurred by the artist's move to Spoleto, Italy, in 1980.

While these works depart from the more muted palette and systematic logic of LeWitt's early pencil and later wall drawings, they also reflect his continued interest in using the cube as a basic geometric element. Equally significant are the tonal variations achieved in LeWitt's ink wash wall drawings, which result from layering only primary colors and gray. While the spirit of *Wall Drawing #520* is one of modesty, simplicity, and restraint, the visual results are lush.

DRAWN BY
Michael Abelman, Rachel Houston, Gabriel Hurier, Eileen Lammers, Clint Reams, Jon Shapley, Patrick Sheehy

FIRST INSTALLATION
Whitney Museum of American Art, New York, April 1987

FIRST DRAWN BY
Catherine Clarke, Douglas Geiger, David Higginbotham, Anthony Sansotta, Patricia Thornley, Jo Watanabe

*Wall Drawing #520: Tilted forms with
color ink washes superimposed*, 1987/2013
Colored ink wash on wall
Three walls: 148 x 450 inches;
148 x 219 inches; 148 x 544 inches

Lent by the Estate of Sol LeWitt

SOL LEWITT

AMERICAN, 1928–2007

Sol LeWitt, a pioneer of minimal and conceptual art, exhibited five structures in his first solo exhibition in 1965. With matter-of-fact titles like *Floor Structure* and *Wall Structure*, the rectangular black wood forms signaled his lifelong commitment to an elemental geometric vocabulary, as well as a sensitive consideration for the architectural context of his work. The wall is never merely a backdrop in LeWitt's art; it assumes primary importance as a critical component in many of his three-dimensional structures and as the surface upon which his wall drawings are painted or drawn.

Circle with Towers appears as a low circular wall capped at regular intervals by eight rectangular towers made of pale gray concrete blocks. The outdoor structure possesses a discernible logic and rhythm: the concrete towers are four blocks wide while the low walls between them are eight—a perfect 1:2 ratio. The concrete blocks are laid by hand, one block at a time, by local masons. Like many of LeWitt's works, *Circle with Towers* demonstrates the artist's generosity in welcoming others to interpret his work, including the artists and craftspeople who create his artistic visions.

LeWitt introduced concrete block into his work in the 1980s. A humble material, it appealed to his interest in making art that privileged concepts over surfaces. He also liked that the rectangular forms could be stacked on end so that the cube, or square, becomes a repeating motif. While LeWitt's work evolved in significant ways over the course of his career, the cube appears at each phase and in every medium, from sculpture to photography. The square and cube were both crucial elements in LeWitt's vocabulary, both as elemental units and in reference to grids made by other artists throughout the twentieth century.

INSTALLED BY

John P. Adame, Christopher J. Alejos, Jesse Carbajal, Rico Aruizo Epifanio, Gustavo L. Gaytan, Isacc Hernandez, Alfredo Martinez, Oscar Martinez, Reymundo Medina, Robert Montalvo, Carl Bermudes Pacheco, Gerardo Sanoteli, Albert A. Suniga, Kenneth O. Tarter Jr., Arthur Trujillo, Francis Munoz Vazquez

The project was carried out by Rudd & Adams Masonry, Inc., under the supervision of Austin Commercial contractors, and Jeremy Ziemann, Principal Oversight, Sol LeWitt Structures.

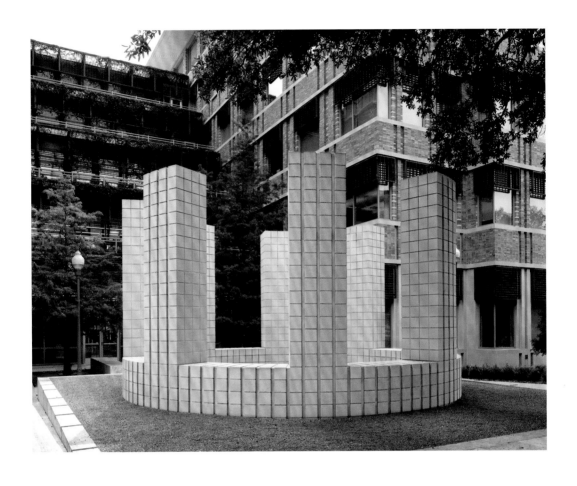

Circle with Towers, 2005/2012
Concrete block
168 inches high, 308 inches in diameter

Purchase, Landmarks, The University of Texas
at Austin, 2011

DONALD LIPSKI

AMERICAN, BORN 1947

Like the Dada artists of the 1910s and Pop artists of the 1960s, Donald Lipski uses ordinary objects from daily life—things easily recognized but not necessarily having a single or specific intended meaning—and assembles them in whimsical and surprising ways. He is best known for extensive arrangements of found objects that appear to have little or nothing in common, often using humorous and perplexing titles to suggest meanings. Unlike formalist artists whose goal is visual beauty, Lipski's approach to art is primarily conceptual; that is, he seeks to express ideas and elicit viewer reactions. The visual appeal, however, remains strong.

The West consists of two spherical buoys, each measuring five feet in diameter. Such buoys mark deep-water shipping channels and are often used to indicate where large commercial and military ships are permitted to anchor offshore. Their typical place is floating on open bodies of water; but situated on dry land, the buoys are no longer functional, like fish out of water. Instead of providing secure anchorage to ships, they are shackled uselessly to each other. To their surfaces Lipski adhered regular pennies that he deliberately corroded, alluding to the predominance of capitalism in Western values and the global reach of the American dollar.

A certain conversation starter, *The West* combines items that offer visual allusions, inviting the viewer to engage in the mental work of supposing. For some, the title of the piece implies uncharted territory, while the suggestive shape of the buoys hints at the brute force and masculine energy needed to conquer the unknown. The pennies attached to the surface of the sculpture—heads on one buoy and tails on the other—imply the odds of a great gamble. Like much of Lipski's sculpture, understanding *The West* is similar to teasing apart a poem—multiple meanings can be coaxed out and revealed over time.

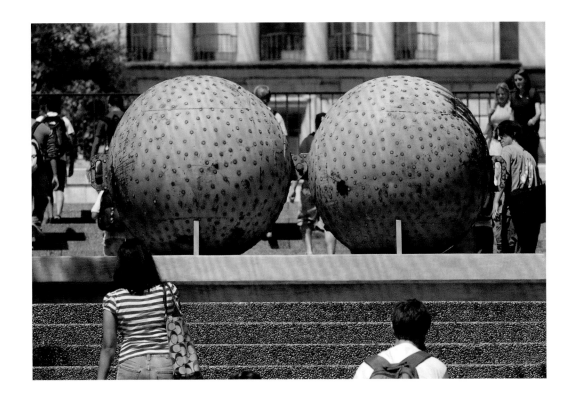

The West, 1987
Painted steel, corroded copper pennies,
and silicone adhesive
Each sphere 60 inches in diameter

Lent by The Metropolitan Museum of Art
Purchase, Louis and Bessie Adler Foundation,
Inc. Gift (Seymour M. Klein, President), 1988
1988.90a,b

SEYMOUR LIPTON

AMERICAN, 1903–1986

Best known as a mid-century sculptor, Seymour Lipton began his career as a dentist after graduating from Columbia University in 1927. He had no formal training in art, but his manual skills served him well. As a sculptor, he evolved a style that diverged from anatomical realism. Like others of his generation—for example, Alexander Calder (1898–1976) and David Smith (1906–1965)—Lipton recognized that metal sculptures had more resonance in the Machine Age. He started bronze casting in 1940–1941; however, after the bombing of Pearl Harbor, the use of metal was restricted to the war effort, so Lipton worked intermittently with sheets of scrap metal.

Like many other sculptors in the decade after World War II, Lipton created abstract works that suggest, rather than literally depict, human figures. The vertically arranged *Pioneer* evokes a standing form, with two long legs and a jumble of arms topped by the absence of a recognizable head. While the title *Pioneer* implies a brave and bold leader, the figure is static without forward motion. This juxtaposition may serve as a metaphor for the ambiguity of modern ideas and ideals—namely, that the heroic stereotypes of the past may not be as relevant in our contemporary world.

Lipton's sculptures from the 1940s express the darker side of human nature. By the 1950s, however, his work had begun to suggest regeneration and rebirth. In this context, *Pioneer* can be viewed as representing the cyclical process of life and death. On the whole, the 1950s was a time of rebuilding, growth, and prosperity; yet the era was also marked by new anxieties, including the Cold War and conflicts in Korea. Thus, Lipton's postwar abstract sculptures, while optimistic, often convey the fragility of life with a lurking sense of threat.

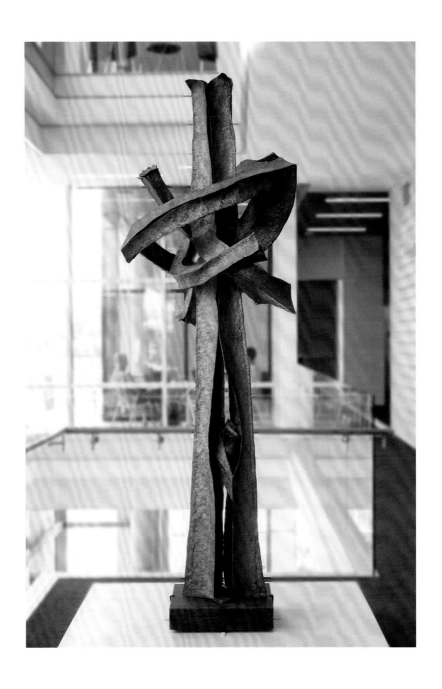

Pioneer, 1957
Nickel silver on Monel
94 × 32 × 30 inches

Lent by The Metropolitan Museum of Art
Gift of Mrs. Albert A. List, 1958
58.61

SEYMOUR LIPTON

AMERICAN, 1903–1986

Seymour Lipton, a self-taught artist, found inspiration in nature, machinery, and the human figure. Reflecting on the sociological concerns of his time, he wanted to express the emotional, psychological, and spiritual tensions of balancing conflict: "Sculpture is used by me to express the life of man as a struggling interaction between himself and his environment." Lipton developed a style predicated on tension between curved and straight elements, internal hollows and external shells—an aesthetic that is reinforced by his choice of medium.

Like *Pioneer*, this sculpture presents another of Lipton's totemic figures; however, *Guardian* conveys a more ominous tone. The "body" consists of a solid rectangle below an opening with a massive hollowed spherical form that suggests a head with a gaping maw. Although the eyeless head appears to be roaring a warning or about to attack, the title *Guardian* asserts a positive meaning, one of protection.

Throughout his career, Lipton created a series of monumental, heroic sculptures as expressions of the basic idea of human existence, believing that life is precious but fragile, and that strength is necessary in order to protect it. The more intimidating the appearance, the more effective Lipton's pieces are at conveying a sense of defending the weak against harm, the good against evil. Of his sculptures, the artist said, "Man is still an animal. This was shown to us in the past, but the war showed it up more definitely, more clearly. I used all the means at my disposal…to find images of horror. Subsequently, however, I came to feel that Hell below wasn't the whole story, that man had hope."

Guardian, 1975
Nickel silver on Monel
96 ¾ × 39 ¾ × 26 ¼ inches

Lent by The Metropolitan Museum of Art
Gift of the artist, 1986
1986.276.4

SEYMOUR LIPTON

AMERICAN, 1903–1986

In 1951, Seymour Lipton discovered the advantages of Monel, an industrial alloy available in strong, thin sheets, which he heated and shaped into abstract forms. Using soldering irons and welding torches, the sculptor braised thin rods of nickel, silver, lead, and copper onto the shaped surfaces, simulating variegated textures, ranging from coarse to delicate. Midway through his career, Lipton began creating small, metal armatures as models for full-scale sculptures. Declaring that "you can't turn a drawing around," Lipton fabricated three-dimensional sketches from thin sheets of metal, spot-braising joints with a small torch.

Compared to *Pioneer*, the sculpture *Catacombs* is more abstract and architectonic. Although there is no explicit narrative, the main forms consist of hollow, dark interiors enclosed by sheet metal gleaming in the light. The three main vertical elements resemble totemic figures clustered together and holding up a smaller fourth form, perhaps a child or ceremonial offering. The grouping suggests a familial or religious ceremony, such as a baptism or burial.

The last phase of World War II—particularly the revelations of genocide in Nazi concentration camps and the nuclear devastation in Japan—prompted Lipton to address somber themes, expressed metaphorically. As with many of his works, Lipton chose a title that provokes speculation and interpretation. The term "catacombs" refers to any underground cemetery, but is most often associated with the subterranean refuges and burial places of early Christians who hid from persecution during the Roman Empire. The three "figures," each of which consists of a single, entirely hollow, concave form, found an environment in which to commune. Viewers might deduce that Lipton meant to represent these physical bodies as temporary shells, a belief that is common to many religions.

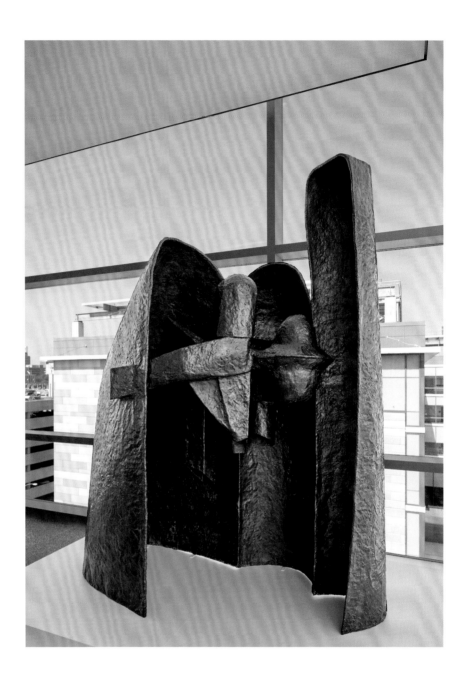

Catacombs, 1968
Nickel silver on Monel
83 × 68 × 32 inches

Lent by The Metropolitan Museum of Art
Gift of the artist, 1986
1986.276.3

BERNARD MEADOWS

BRITISH, 1915–2005

At age sixteen, Bernard Meadows quit school and worked to earn money to study painting at the local art school. He then apprenticed under the sculptor Henry Moore (1898–1986), from whom he learned about direct carving, the biomorphic forms of surrealism, and, perhaps most importantly, the benefits of preliminary drawing to reconcile sculptural ideas.

Early in his career, Meadows mainly sculpted abstract animal motifs as symbols of the human condition. In 1960, when he turned forty-five, he was inspired by a visit to Florence, Italy, where he saw Roman and Renaissance sculptures of emperors and generals in classical armor. For the next five years, Meadows concentrated on a series of twenty sculptures of human figures clad in armor. In his words, these "figures are armored, aggressive, protected, but inside the safety of the shell they are completely soft and vulnerable."

Augustus refers to the powerful Roman emperor, who ruled from 27 BCE to 14 CE. Under his leadership, the empire expanded and solidified its military and political domains in southwestern and southeastern Europe, northern Africa, and the Near East. Significantly, the empire began to enjoy a new era of internal peace known as the Pax Romana. Meadows' *Augustus* confronts viewers with its physical bulk, but the impression is not that of a triumphant ruler. The armor covering the massive torso is cut by deep crevices, and some areas have rough edges, implying that the emperor and his empire have suffered hardships. The once-powerful arms have withered to useless appendages. Like many men of his generation, Meadows was profoundly affected by the Great Depression of his early childhood as well as his later service in World War II. *Augustus* suggests that in the modern era, earlier concepts of class structure and imperial rule no longer survive, except in damaged form.

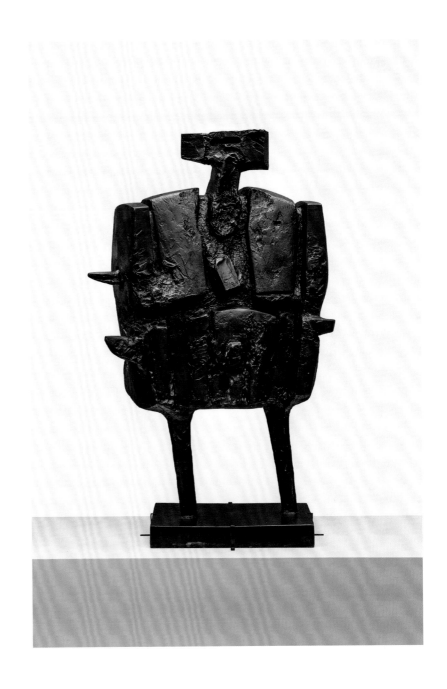

Augustus, circa 1962
Bronze
64 ¾ × 39 ½ × 22 ½ inches

Lent by The Metropolitan Museum of Art
Gift of Genia and Charles Zadok, 1988
1988.120

ROBERT MURRAY

CANADIAN, BORN 1936

During the summers in the 1950s and '60s, Robert Murray studied at the Artists' Workshop in Emma Lake, Saskatchewan, Canada, a magnet for abstract artists. A painter and printmaker, Murray made his first sculptures during his stay at the innovative Instituto Allende in San Miguel, Mexico, in 1958–1959. In 1960, he moved to New York, where he made his first large, painted steel sculpture. Formalism was at its height: driven by critic Clement Greenberg (1909–1994) and ascending to dominance in the art world, it argued that the value of art lies in form rather than content. In this environment, Murray found a ready audience for his new works.

Murray begins by making a small model from cardboard or thin aluminum sheets, which he bends, folds, and cuts, without preliminary drawings. According to the artist, "I can do a great many of them almost as easily as a drawing. In fact, they are really three-dimensional drawings." Murray then coordinates with the Lippincott foundry in North Haven, Connecticut, to produce the full-size work. The sculpture is not merely an enlargement of the maquette; the artist makes adjustments as needed during fabrication.

Murray's earliest sheet-metal sculptures were upright columnar configurations that were made by cutting and bending steel plate, usually in strict verticals, horizontals, and right angles or half-right angles and corners. He does not use prefabricated shapes; he starts with a flat sheet of metal and uses an industrial roller to create a curve. In 1974, Murray's sculptures became more freely formed than before, with "crunches" and folded edges, almost like paper. This seemingly casual method of working with the material may owe a debt to the aesthetics and practice of Anthony Caro (1924–2013), whose sculptures inspired a new spontaneity in metal sculpture in the 1960s.

The term "Chilkat" refers to the northwestern region of the artist's native British Columbia, Canada. The Chilkat River flows fifty-three miles from the Chilkat Glacier to the Chilkat Inlet. The area was named for the indigenous inhabitants, a subgroup of the Tlingit Indians, who are renowned for their carvings and weavings.

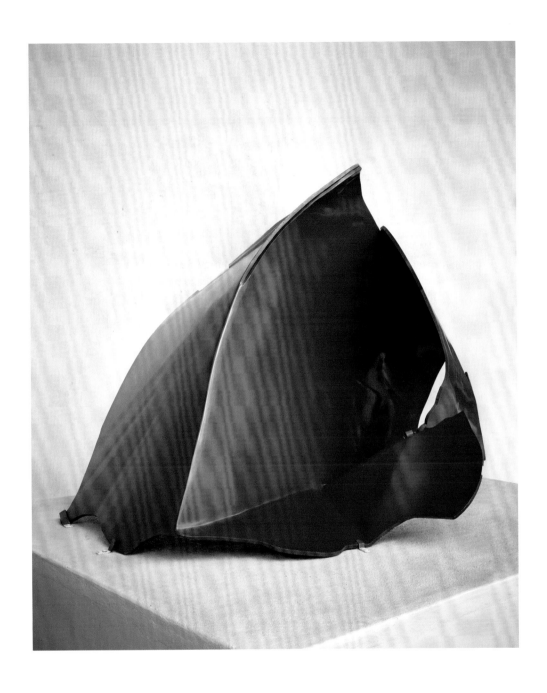

Chilkat, 1977
Painted aluminum
51 × 61 × 81 inches

Lent by The Metropolitan Museum of Art
Purchase, Anonymous Gifts, 1978
1978.83

EDUARDO PAOLOZZI

BRITISH, 1924–2005

Like Bernard Meadows (1915–2005), Eduardo Paolozzi was deeply affected by the politics and realities of World War II. Before the war, he studied at the Slade School of Art in London and was much impressed by the ideas of surrealism. He worked primarily in collage—a favorite of Dada and surrealist artists because disparate images could be juxtaposed to provoke an intellectual or psychological reaction.

Shortly after the war, Paolozzi made a series of collages combining pictures of classical sculptures with images of modern machines. The works are an expression of the turmoil caused by the old European order colliding with the new technological world. Applying the methodology of collage to sculpture in the 1950s, he gathered old machine parts and cast-off technology components, which he pressed into slabs of wax. After casting them into bronze, Paolozzi welded the pieces together into semiabstract figures.

These sculptures relate to the emergence of cybernetics in the arts, literature, philosophy, and science. The idea of automata (humanlike machines) had appeared in science fiction, in tandem with the increasing use of machines during the Industrial Revolution of the nineteenth century. After World War II, scientists began publishing accounts of efforts to merge electronics with human capabilities, making the robots of science fiction seem feasible. In stories, robots were usually viewed as ominous: anthropomorphic yet inhuman, intelligent yet soulless, an uncontrollable threat to human supremacy. Unlike today, the robots of the 1950s and '60s were rarely portrayed as sympathetic.

Paolozzi's robotoid sculptures have irregular contours and seemingly ravaged surfaces. They appear damaged, as if survivors of a catastrophe. *Figure* lacks both arms and a head, and its bulky legs and feet appear heavy and difficult to move. Its small step forward may allude to modern society's struggle to rebuild after the war. Made from aggregate scraps and refuse, *Figure* emerges from the wreckage, confirming life after a period of monumental destruction.

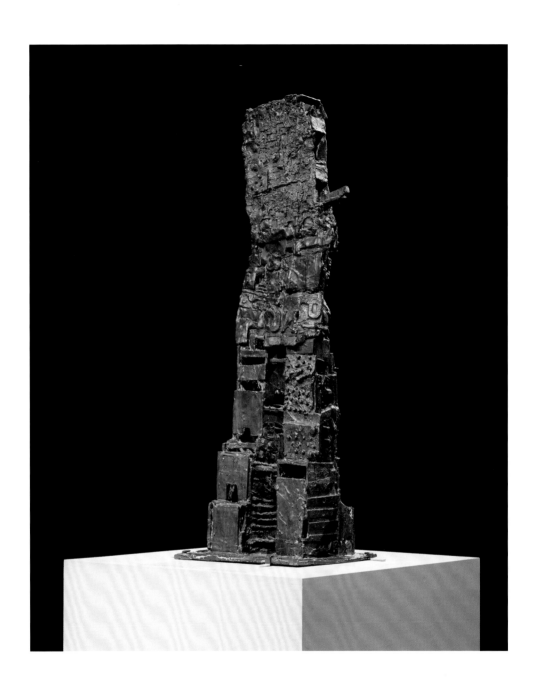

Figure, circa 1957
Bronze
36 ¼ × 12 ⅜ × 10 ½ inches

Lent by The Metropolitan Museum of Art
Gift of Margaret H. Cook, 1996
1996.439

JOSÉ PARLÁ

AMERICAN, BORN 1973

Multimedia artist José Parlá finds inspiration in the history and experience of urban environments. His work is characterized by exuberant compositions featuring multilayered, viscous surfaces with dense pigments and overlapping calligraphic arcs. *Amistad América* is composed of these elements, however, the mural's scale and metaphoric complexity are unprecedented.

Parlá began painting as an adolescent, experimenting with graffiti. What he learned would inform his mature artistic practice. In addition to mastering the technical agility and sheer speed required for clandestine street painting, Parlá also developed an appreciation for the rigor of physical performance and an awareness that his body could translate the rhythms of music into visual expressions. Equally significant, Parlá acquired a lifelong affinity for walls: as a substrate for painting, as witness to history, and as cultural metaphor. In their scarred and decayed surfaces, he recognizes our innate drive to make marks—a lineage that spans primeval cave paintings to contemporary urban scrawls.

Amistad América renders Austin through Parlá's eyes, with a palette that evokes its vast skies, abundant nature, and pulsing urban core. The painting suggests a continental map that connects Austin to a much larger ecology. It also contains obscured fragments of calligraphic letters that form the words *Austin*, *Guadalupe*, and *King*. These not only locate the mural physically at the intersection of Austin's Guadalupe Street and Martin Luther King Jr. Boulevard but they also acknowledge the work's symbolic position at a place of Latinx and African American history and culture.

The painting offers a sweeping visual landscape that conjures Austin itself while situating the city within the larger geopolitics of the Americas. The title makes that connection concrete: *La Amistad* was a nineteenth-century Spanish trading ship that plied the Caribbean. In 1839 its African slave cargo famously mutinied, eventually re-establishing their liberty. Parlá chose the word both to commemorate this turbulent history and to celebrate its conciliatory and optimistic resonance: from Spanish, *Amistad América* translates to *Friendship America*.

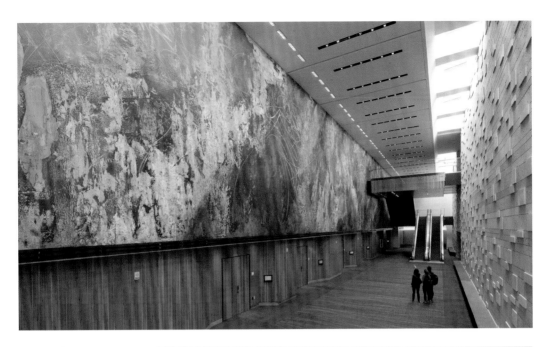

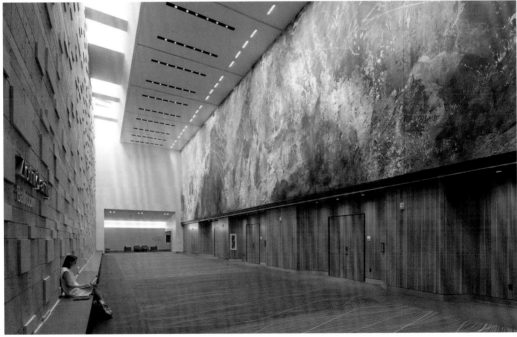

Amistad América, 2018
Acrylic, plaster, and ink on canvas
304 x 1947 ¾ inches

Commission, Landmarks, The University of
Texas at Austin, 2018

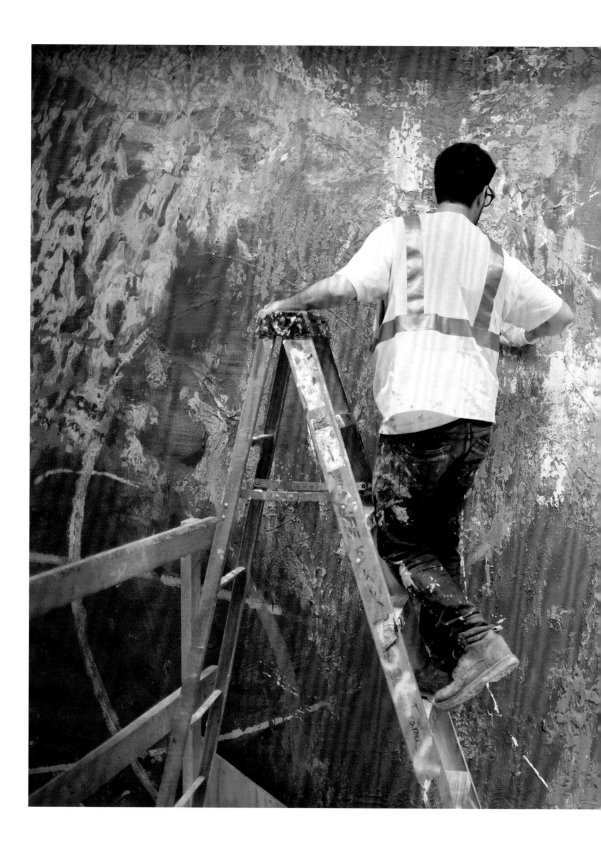

BEVERLY PEPPER

AMERICAN, BORN 1924

After World War II, Beverly Pepper studied art in Paris at the studios of cubist painters Fernand Léger (1881–1955) and André Lhote (1885–1962), and sculptor Ossip Zadkine (1890–1967). During this time she developed geometric and biomorphic abstract styles derived from European modernists. Turning from painting to sculpture in 1960, Pepper first carved in wood, a plentiful and inexpensive material; however, instead of using hand chisels, she preferred power tools.

In 1962, along with ten other sculptors, she was invited to Spoleto, Italy, to use local steel factories as studios. The other artists included well-established masters of abstract metal construction such as Alexander Calder (1898–1976) and David Smith (1906–1965). Unfamiliar with welding, Pepper apprenticed with an ironmonger and soon made her first steel sculpture, nearly eighteen feet tall. After her time in Spoleto, she sculpted only in metal and favored monumental scales, mostly for installation outdoors in urban spaces.

It was virtually unprecedented for women to use the physically arduous, industrial methods of cutting and welding heavy sheets of steel in the 1960s. Unlike many sculptors of her generation, Pepper established her own well-equipped studio because she preferred to fabricate the sculptures herself rather than delegate the task to others.

By the 1980s, Pepper had moved from the geometric constructions with systematic repetition advocated by minimalist sculptors toward autonomous forms grouped together. *Harmonious Triad* consists of three tall and very slender columns on a low, square pedestal. These verticals may suggest standing figures, but Pepper preferred them to be interpreted as pure abstraction. Here, we see a delicate interplay of shapes and an exquisite subtlety of form and placement.

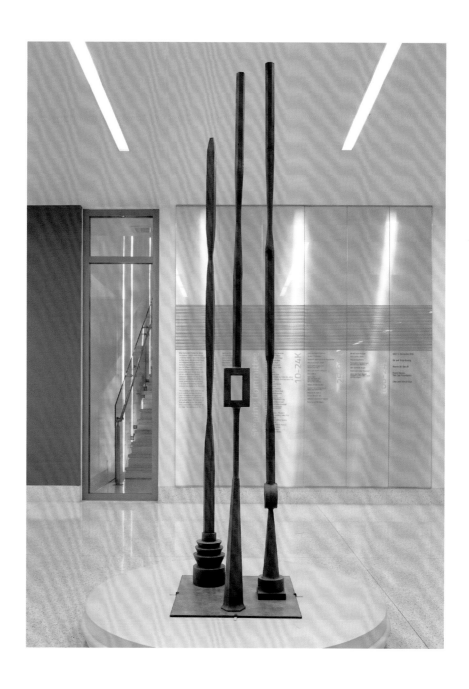

Harmonious Triad, 1982–1983
Cast ductile iron
96 × 26 × 24 inches

Lent by The Metropolitan Museum of Art
Gift of Charles Cowles, 1983
1983.521a-d

JOEL PERLMAN

AMERICAN, BORN 1943

Using industrial-grade steel plate to fabricate geometric abstract sculptures, Joel Perlman espoused the purely visual aesthetics championed by the critic Clement Greenberg (1909–1994), in which form takes precedence over subject. Perlman's works of the 1980s are essentially flat arrangements best seen from a frontal viewpoint, like paintings. He drew inspiration from the abstract compositions of the vanguard Russian artists Kasimir Malevich (1879–1935) and El Lissitzky (1890–1941). Although created in the 1910s and '20s, their work—in which the purity of geometric forms is enlivened by being tilted on a diagonal axis—was rediscovered in the 1960s and '70s by artists like Perlman.

The composition of *Square Tilt* may owe a debt to the urban architecture of Manhattan, which Perlman could see through his studio windows. Though not meant to directly quote the soaring cityscape, *Square Tilt* and other works created at this time capture qualities of the city: powerful, broad, and monumental. Perlman allows the inherent strength and durability of the industrial steel to play a large role in the overall scheme.

Square Tilt typifies Perlman's best-known compositions, which suggest portals or gateways: a square or rectangular frame surrounding a large opening. The sculpture functions as a window in any setting, offering viewers the opportunity to see through a physical and metaphoric frame. Seen indoors against a blank wall, the work invites appreciation of its abstract vivacity. In other settings, especially outdoors, the large central opening incorporates its environment. *Square Tilt* consequently carries connotations of openness, far horizons, and passage into other domains. Rectangles of steel plate are attached to the frame, introducing a harmonic interplay of forms. Despite its considerable size and steel construction, *Square Tilt* conveys an impression of airy weightlessness.

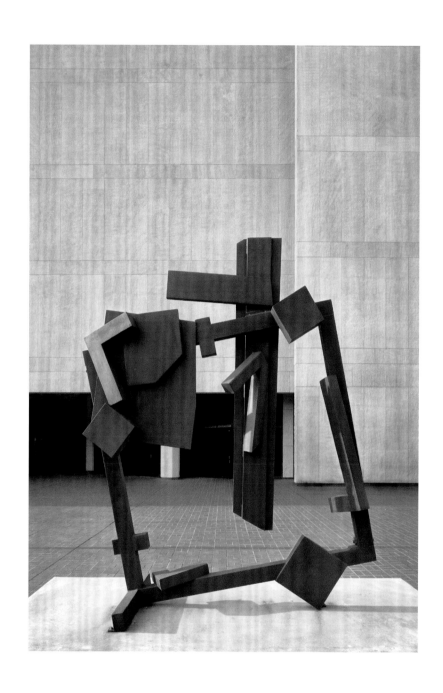

Square Tilt, 1983
Steel
120 × 96 × 36 inches

Lent by The Metropolitan Museum of Art
Gift of Mr. and Mrs. L. William Teweles, 1986
1986.442a-d

ANTOINE PEVSNER

FRENCH, BORN IN RUSSIA, 1886–1962

Antoine Pevsner began his career as a painter. A sojourn in Paris from 1911 to 1914 introduced him to cubism and futurism, two radical new approaches to making art. After the Soviet Union withdrew from World War I in 1917 and the threat of a draft was over, Pevsner and his brother, sculptor Naum Gabo, returned to Moscow to participate in the utopian fervor of building a new egalitarian society. Pevsner began sculpting works that could, in theory, be adapted for use in architecture and urban design projects to serve the general public. His sculptures were strongly influenced by his brother's innovative constructions and were small in scale due to severe shortages of materials in the fledgling Soviet Union.

In 1923, Pevsner immigrated permanently to France. In the exhilarating art environment of Paris, he joined other artists who endorsed the new aesthetics of geometric abstraction. Early in the twentieth century, the Italian futurists had conceived the basics of a visual language for the new Machine Age. Their ideas were widely disseminated throughout Europe and the Americas by the mid-1920s. Pevsner developed a style based on convex and concave forms, primarily funnel-shaped vortices; he adopted the futurist emphasis on diagonal linear elements, originally known as "lines of force." Such art was suppressed during the Nazi occupation of France during World War II, but reemerged strongly in the early 1950s.

After the devastation and destruction of seven years of combat and oppression, Europeans intensely hoped for a lasting peace as they rebuilt their lives and their countries. *Column of Peace* was conceived as a maquette for a large memorial that was never realized. The sculpture consists of intersecting, upwardly rising diagonals. To viewers familiar with the original utopian meanings underlying abstract art, the message is one of hope for progress. By the time Pevsner conceived his *Column of Peace*, this abstract visual language was widely understood.

Column of Peace, 1954
Bronze
53 × 35 ½ × 19 ¾ inches

Lent by The Metropolitan Museum of Art
Gift of Alex Hillman Family Foundation,
in memory of Richard Alan Hillman, 1981
1981.326

MARC QUINN

BRITISH, BORN 1964

In his sculptural series *The Archaeology of Art*, Marc Quinn creates monumental forms of seashells housed in the British Natural History Museum. The conch for *Spiral of the Galaxy* was scanned in three dimensions and then a mold was created and cast into bronze. The resulting figure is familiar in its proportion and surfaces, but strange because it no longer invites intimate handling. Its altered material and scale transform the vessel into a solid, architectural form that occupies public space and affects the urban ecosystem.

Quinn first came to public attention in the early 1990s through his affiliation with the Young British Artists (YBAs). Among his earliest and best-known works is *Self* (1991), a cast of his head made from ten pints of Quinn's frozen blood, an amount equal to the volume in his body. In a 2013 interview, the artist said that the YBA movement had been about "bringing real life into art." Both *Self* and *Spiral of the Galaxy* explore the holistic and metaphysical, a desire to translate the substance of life into image.

By dramatically altering the shell's material, scale, and surroundings, *Spiral of the Galaxy* acquires a mythical aspect, quivering between the real and the fantastical. Quinn has called seashells "The most perfect pre-existing sculptural 'readymades' in our natural world," referring to the graceful intricacy of their forms and the wonder of their natural production.

The sliding scales along which a society measures fragility and strength, ephemerality and endurance, even life and death, are central concerns of Quinn's art. Throughout his career, he has explored the unstable margins of life and the meanings we find in them: the vital interconnectedness of all life forms across time; the desire to still a passing moment or to live forever; and the prospect of living in harmony with nature and other people.

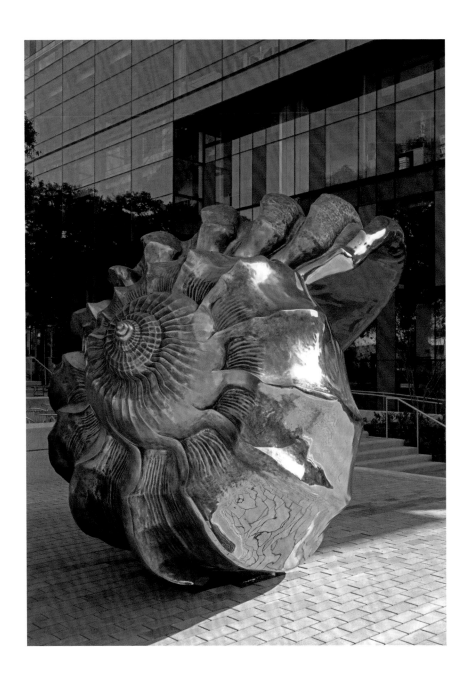

Spiral of the Galaxy, 2013
Bronze
131 x 196 x 100 inches

Purchase, Landmarks, The University of Texas
at Austin, 2014

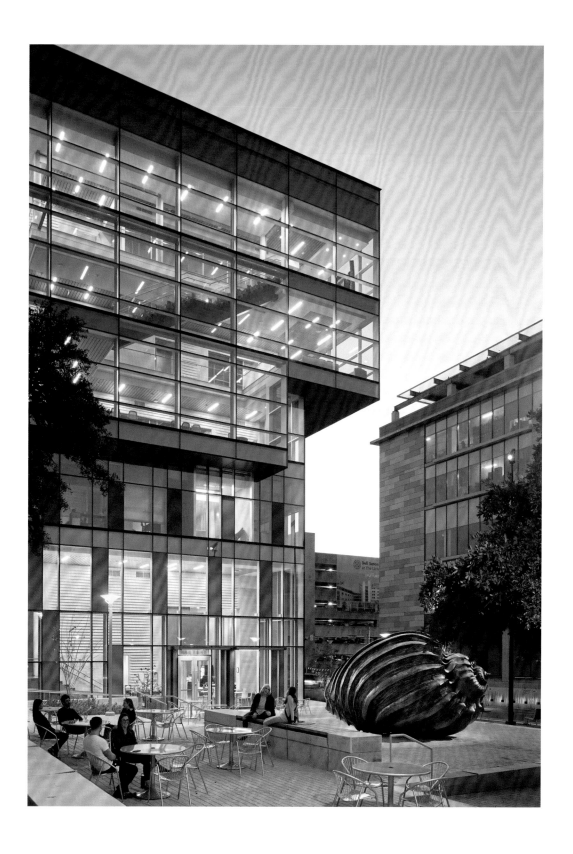

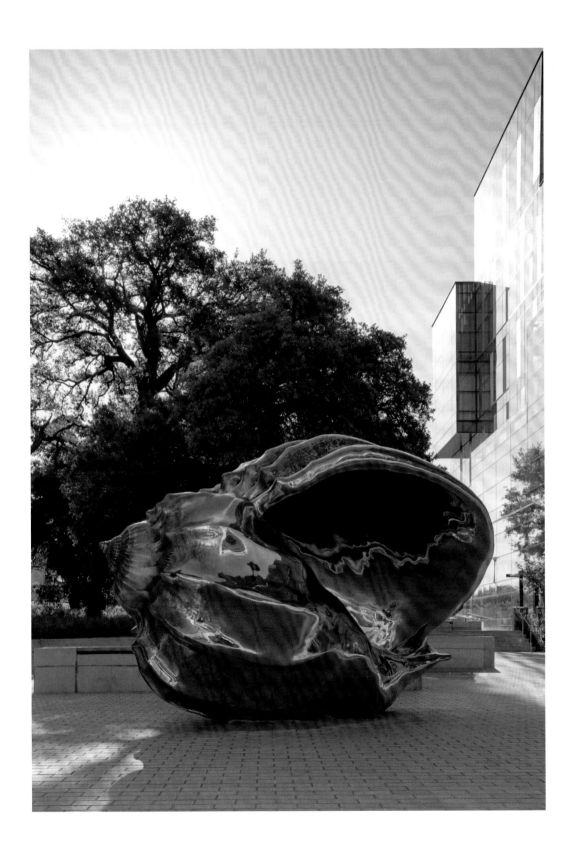

CASEY REAS

AMERICAN, BORN 1972

Casey Reas has emerged as one of the leading artists in the genre of software art, defining both the practice in this field and the theoretical discourse surrounding it. In 2001, Reas partnered with fellow MIT student Ben Fry (b. 1975) to initiate and create Processing, an open-source programming language and visual environment for coding. It is used around the world for visual prototyping and for programming images, animation, and interactivity.

Reas' software art typically explores systems, specifically their emergence and underlying instructions and conditions. Instructions form the basis of all generative art, in which an autonomous system—such as a machine or computer program—creates a work of art based on rules outlined by the artist. The instruction-based nature of software art points to art-historical roots in conceptual art. Reas was profoundly influenced by the work of Sol LeWitt (1928–2007), who generated works through a set of written instructions for others to interpret.

A Mathematical Theory of Communication blends conceptual art and information science by merging aspects of both in order to create an experiential data landscape. For this commission, Reas captured television images with an antenna, then processed the images using algorithms—or "instructions"—he designed. The abstracted images were processed again, generating some forty thousand results, from which Reas chose two perspectives with converging energy. The images were inkjet printed to create the mural on two walls.

The title of this piece is borrowed from a highly influential article published in 1948 by Claude Shannon (1916–2001), which is considered one of the founding texts in the field of information theory. Shannon proposed that messages are transformed into a signal by a transmitter, then sent through a channel, decoded by a receiver, and finally delivered to a destination. Reas used the title to capture the visual and conceptual theory of communication unfolding in his art, emphasizing that, as viewers, we become receivers who decode the imagery.

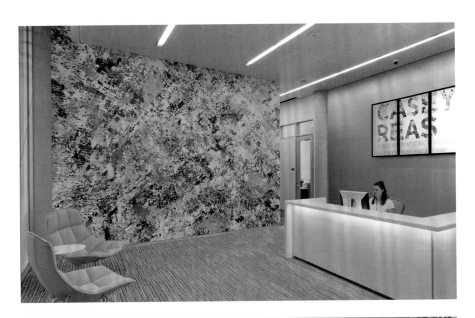

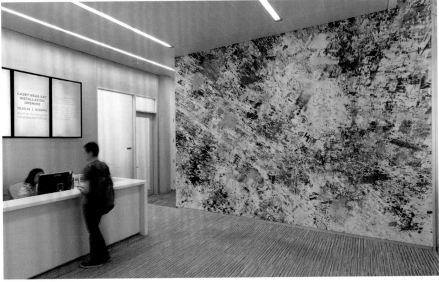

*A Mathematical Theory of
Communication*, 2014
Inkjet print
Two walls: 167 × 198 ¼ inches;
167 ½ × 190 ¾ inches

Commission, Landmarks, The University of
Texas at Austin, 2014

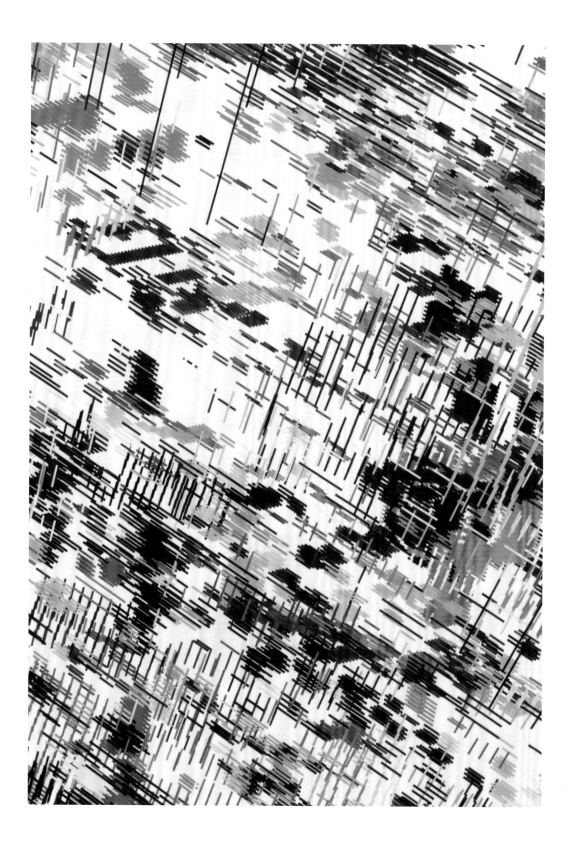

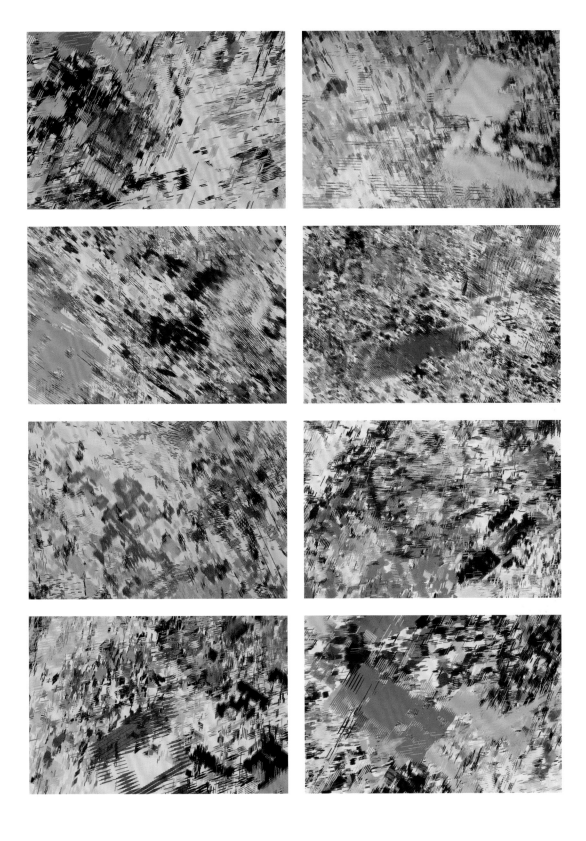

PETER REGINATO

AMERICAN, BORN 1945

In the late 1960s—the era in which sculpture was dominated by the modernist aesthetic of geometric abstraction—Peter Reginato found rigid geometries too anonymous and lacking individualism. He preferred the visual energy and physical buoyancy of biomorphic shapes used in a lighthearted way, harking back to the playful qualities of earlier constructions made by Alexander Calder (1898–1976), Julio Gonzalez (1876–1942), Pablo Picasso (1881–1973), and David Smith (1906–1965).

Reginato begins by drawing fluidly contoured shapes on sheet metal, which he then cuts out with a blowtorch. He joins them together at the edges with spot welds so that the forms appear to float in a delicate dance. Through his work, Reginato aims to express the spontaneity of drawing in three dimensions: "I like to think that all my rippling, swelling forms could easily be flying wildly in space." His vibrant color palette further animates his sculptures.

The title *Kingfish* makes reference to a character from the classic television show *Amos 'n' Andy,* which aired from 1951 to 1953. George "Kingfish" Stevens was a huckster who tried to lure Amos and the gullible Andy into get-rich-quick schemes. The slick character was a childhood favorite of the artist, who appreciated Kingfish's flamboyance and street smarts. According to Reginato, "The sculpture had a 'large personality' just like the character."

By finding his own path apart from the austerity of minimalism and equally distant from Pop art, Reginato's idiosyncratic works have a humor and vitality that is widely appreciated. His sculpture rejects "serious" art; it boasts forms that are playful and brightly colored. The artist once noted, "Essentially my work is joyous."

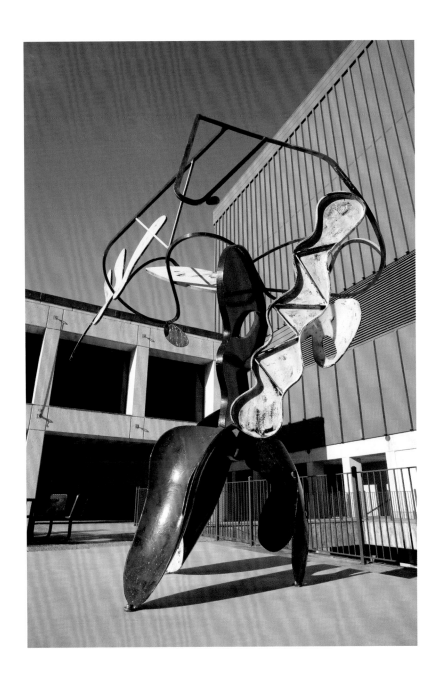

Kingfish, 1986
Painted steel
113 × 121 × 62 inches

Lent by The Metropolitan Museum of Art
Purchase, Lila Acheson Wallace Gift, 1987
1987.226

BEN RUBIN

AMERICAN, BORN 1964

The work of Ben Rubin, a pioneering figure in contemporary media art, communicates patterns of information, thought, and language via electronic media. Whether creating a work of intimate or monumental scale, Rubin composes algorithms and computational systems, often relying upon a selected data source to generate nonlinear results. The transformation of the familiar into the unexpected, captured through gracefully simplified forms, results in works that are quietly provocative and that gently turns viewers into participants.

Visible every evening in the Walter Cronkite Plaza, *And That's The Way It Is* projects an interwoven grid of text from two sources: closed caption transcripts of five live network news streams and archival transcripts of CBS Evening News broadcasts from the Cronkite era, including those housed at the university's Dolph Briscoe Center for American History. Rubin's software scans for various patterns in speech and grammatical constructions, then selects the sequences of text. The artist visually distinguishes these sources by using two typefaces that evoke the technologies of their respective eras: Courier represents the Cronkite material, and Verdana is used for the live broadcasts.

And That's The Way It Is translates the spoken language of televised evening news into written fragments. The layering of information—textual and visual, contemporary and historical—engages the viewer in multiple ways: cerebrally, as a distilled source of information, and viscerally, as a visual experience of luminescent crescendos and diminuendos. The speed and immediacy of live fragments heightens the viewer's anticipation from one composition to the next, while the insertion of historical phrases associates the past with the present. Projected on an architectural scale, the work offers streams of language that suggest the activities transpiring behind the façade of the communication building.

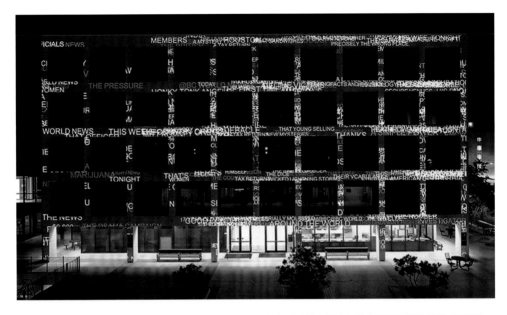

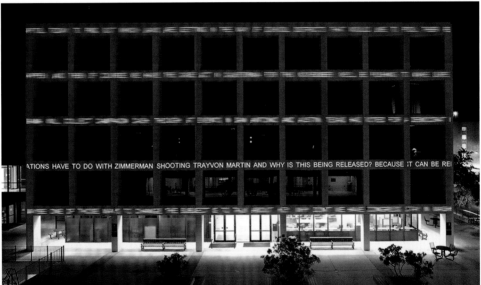

And That's The Way It Is, 2012
6-Channel video projection
Approximately 42 × 120 feet

Commission, Landmarks, The University of
Texas at Austin, 2012

tize obsta...s to new energy prc...cts. REPRESENTATIVE

vor Bush, someone like Bush: well-known, accepta

turning ...n the Republican ta:...ut proposal. Jerry

Bowen, CBS ...ws, with the Reagan ...mpaign in Houston.

nt didn't ...t Bush. In fact, of ...urse, the conventi

Bob Thu...miles aw...r turning ...ing. A ...aficl cl...ing. A ...ature:

.ock. QUESTION: What do you resent about Berglan... Ima

tform Co...in the ...ress alre...d some p...la

had the illness not to use tampons. No correlat

was a s...t was a ...ng story...was the ...that w...obviou...l, obviou

WRIGHT (Majority Leader): We have temporized. We ha

Omitted in 7:00 Eastern Edition Added in 7:00

rmy in Ca

Vietnamese

is there. JERRY VEN: It was over 100 degrees when

fight th

OUNCEMENTS) RATHER The final part of President Carte

errillas

ll almost certainl vote for whomever Re an picks. W

o moderate Republ ans, someoody who co l be sold t

led that pro ask, is quite

e units is

ese separ

Rouge

ing money on his crop. The cash price is down

go. (Col s report)

News, Ch

akeley, C

k

ident Carte

NANCY RUBINS

AMERICAN, BORN 1952

Nancy Rubins is known as a sculptor who upends tradition. As a drafts-man, she maneuvers paper and graphite in unorthodox ways, using them as materials to form constructions. Simply named "drawings," they have the physical presence and spatial dynamism of sculptures in the round. Their forms defy the rectangular shape of a conventional sheet of paper; they are not discrete objects to be framed, and they are not images in any ordinary way. *Drawing* (2007) is jutting, lustrous, and dark, absorbing and deflecting light in a way that complicates its contours and causes the surfaces to expand.

Early on, Rubins explored ways of transgressing boundaries between mediums. *Drawing and Sawhorse* (1975) featured a large sheet of paper thoroughly covered in graphite and draped over a sawhorse to suggest an animated form. In *Drawing* (1974), a penciled sheet of paper was simply slung over a length of heavy rope as if it were laundry on a clothesline. These and other early hybrids of sculpture and drawing introduced a way of using paper to which Rubins would return in the 1990s. The later works on paper sometimes assume a vaguely figurative aspect.

Her graphite marks lend a mineral glint to the surfaces of the drawings and a sense of seismic collision to the abutted edges of the constituent sheets. Generally attached directly to the wall, they sometimes span cor-ners or ceilings, or are allowed to spill onto the floor. These fully three-dimensional works are robust survivors of a working process that leaves them battered, gouged, and ripped; pinned and repinned; and, above all, covered side to side and top to bottom in furiously drawn strokes of dark, glistening graphite. The resulting rough-edged configurations, gathered into folds, resemble sheets of gleaming lead that challenge viewers to re-consider the defining attributes of a drawing.

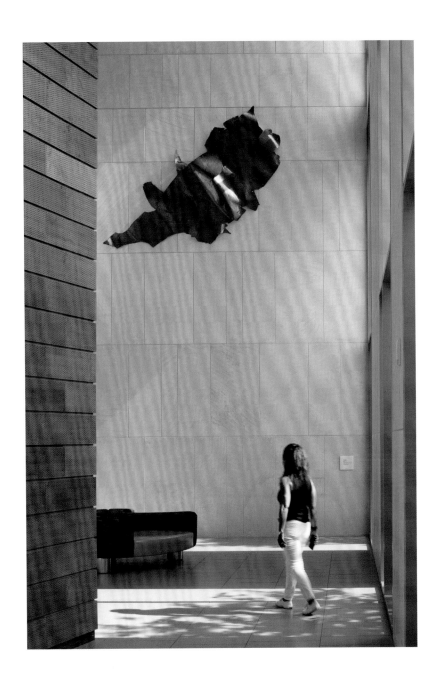

Drawing, 2007
Graphite on rag paper
81 x 132 x 23 inches

Purchase, Landmarks, The University of Texas
at Austin, 2016

NANCY RUBINS

AMERICAN, BORN 1952

Balancing with improbable grace, *Monochrome for Austin* boasts seventy recycled aluminum canoes and small boats clustered at the end of a listing column. It deploys a sense of mass and scale that can be compared to a performer's perfect timing, a characteristic that is ever-present in the work of artist Nancy Rubins. Her sculptures combine delicacy and indomitable strength, a polarity that is even more striking when encountered outdoors.

While a student in the early 1970s, Rubins experimented with sculpture by using wet clay to stick coffee cups to suspended tarps; the cups popped off as the clay dried. In another project, a hybrid of sculpture and drawing, she used a small electric fan to create a work that involved graphite-covered paper spattered with red paint. A more recent exhibition of sprawling sculptures made from vintage animal-shaped playground equipment was titled *Our Friend Fluid Metal* (2014), referencing the molten phase of the constituent metal. Porous boundaries between disciplines and the fluidity of the mediums themselves are qualities that appeal to Rubins.

By the late 1980s, Rubins' constructions had reached colossal proportions. She added trailer homes, water heaters, and mattresses to the materials tethered together, and later, fighter jet wings and fuselages. By the mid-1990s, Rubins had begun to assemble brightly colored fiberglass canoes and kayaks into oversized bouquets that exuberantly flower overhead. The *Monochrome* series, which began in 2010, features the grace of unpainted metal forms. Examples from the series can be found at the Albright-Knox Art Gallery in Buffalo, New York; Gateway Park at the Navy Pier in Chicago, Illinois; and l'Université Paris Diderot in Paris, France.

The vessels evoke a different kind of movement and life than Rubins' earlier work. In contrast to the thundering flight of retired military aircraft, canoes glide gently through the water, suggesting a kind of simple solitude. Swirling on currents of air, the canoes in *Monochrome for Austin* are removed from their associated landscape and combined in a visually precarious mass, giving the impression that they are suspended in time and space.

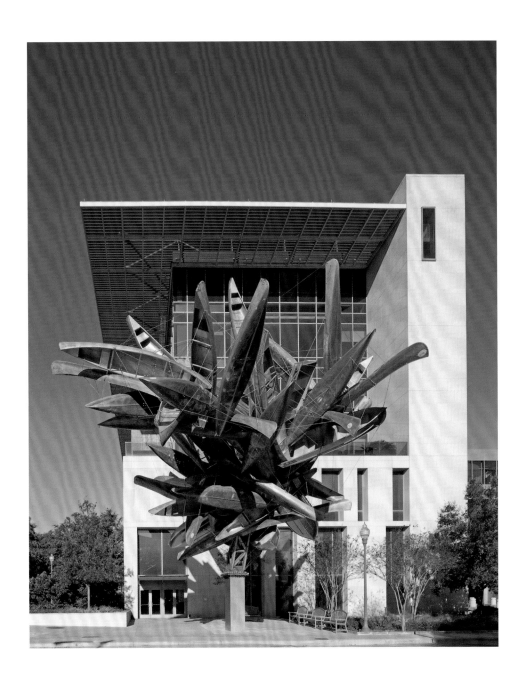

Monochrome for Austin, 2015
Stainless steel and aluminum
600 x 642 x 492 inches

Commission, Landmarks, The University of
Texas at Austin, 2015

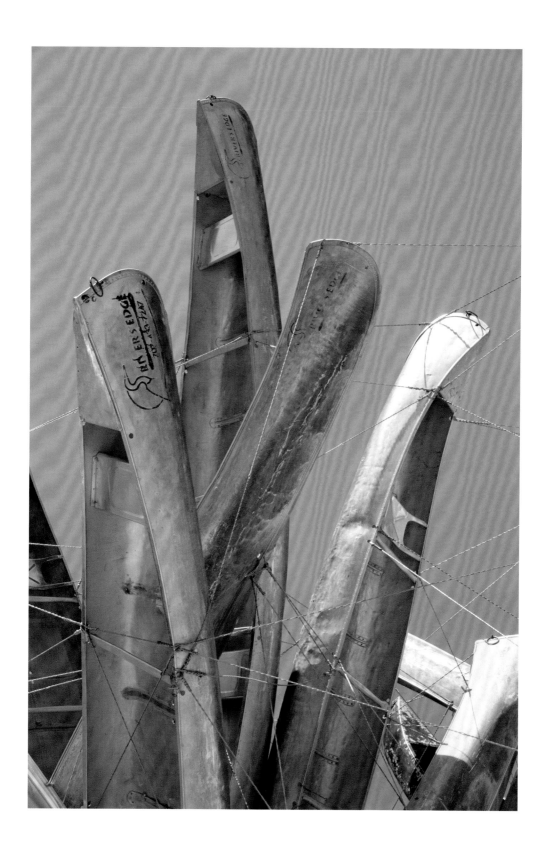

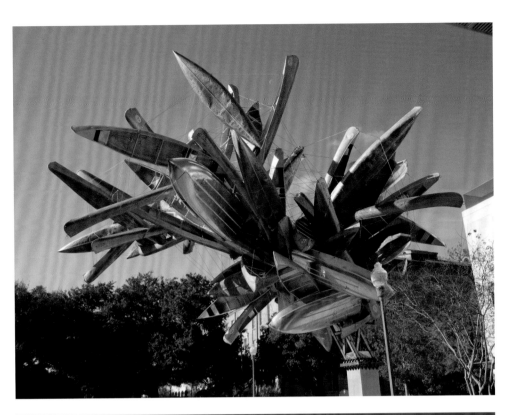

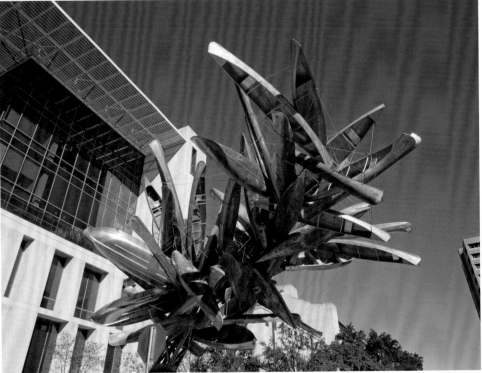

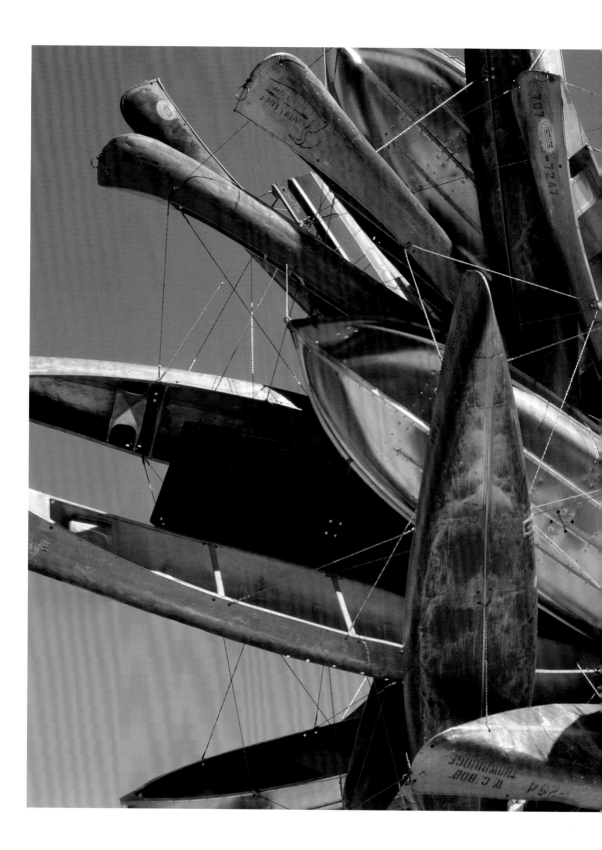

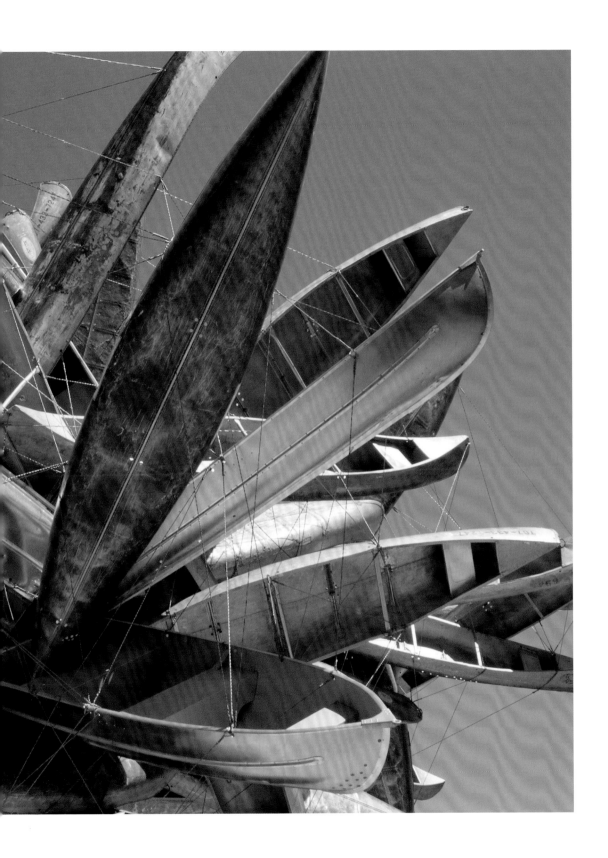

TONY SMITH

AMERICAN, 1912–1980

Tony Smith studied drawing and painting at the Art Students League, followed by a year at the American Bauhaus School in Chicago, where he studied European modern architecture and design. In 1939, he began working for renowned architect Frank Lloyd Wright, whose new plans for mass-produced, modular houses were an inspiration to Smith in the 1940s.

In New York during the 1950s, partly to offset his frustrations as an architect, Smith made abstract paintings of flat curved forms tightly grouped in a gridlike pattern. He started sculpting in 1956 and in five years he began to make small cardboard models of geometric sculptures. Smith used the cube, rhomboid, and tetrahedron as basic "building blocks," which he arranged as modules in a linear configuration. From 1962 until his death, he developed this method using large sheets of plywood. Smith passed these prototypes to industrial fabricators, such as the Lippincott foundry in New Haven, Connecticut, to produce the final version in sheet metal painted a rich black. After his death, his family commissioned the fabrication of the remaining models.

With *Amaryllis* and similar works, Smith helped define minimalism. With its intellectually rigorous, reductive approach, the movement revived the prewar tradition of geometric abstraction. It responded to the unrestrained gesturalism of abstract expressionism forwarded by artists such as Jackson Pollock (1912–1956), Willem de Kooning (1904–1997), and Mark di Suvero (b. 1933).

Considered one of the principal theorists and practitioners of minimalist aesthetics, Smith achieved a unique vitality in his sculptures. *Amaryllis* demonstrates his ability to combine basic modules into an asymmetrical linear arrangement that activates the space it inhabits. As one walks around the work, different configurations emerge and recede; the two stacked polyhedrons can appear flattened or neutralized, firmly grounded or imbalanced. Based on minimalist principles, Smith's complex modules effectively combine elements from primitive and modern architecture, mathematics, and science.

Amaryllis, 1965
Painted steel
135 × 128 × 90 inches

Lent by The Metropolitan Museum of Art
Anonymous Gift, 1986
1986.432ab

JAMES TURRELL

AMERICAN, BORN 1943

James Turrell's artistic medium is light—not paintings that depict light, nor sculptures that incorporate light, but simply light itself. His art offers viewers the opportunity to have unique and intimate experiences with light and to appreciate its transcendent power. Whether through projections, printmaking, or site-specific installations, Turrell's work is influenced by Quaker simplicity and the practice of going inside to greet the light of revelation.

In the 1960s, Turrell began to experiment with light projections and a variety of installations in which exterior light penetrated interior chambers, enabling viewers to perceive space within darkened rooms. In some, he cut away parts of the walls to reveal the sky. These cuts evolved into Skyspaces, rooms with sharp-edged apertures in the ceiling that seem to bring the sky down through the opening, almost within reach.

The Color Inside is Turrell's eighty-fourth Skyspace. Like many others, it is a destination, located on the rooftop of the Student Activity Center. Though Turrell's architectural spaces are reduced to the most essential elements, they retain a simple elegance that makes them enticing. *The Color Inside* is distinctive for its intimate proportions, elegant palette, and brilliant washes of color that can be experienced during specialized light sequences at sunrise and sunset, causing the sky to appear in unimaginable hues. Also available for observation during the day, the Skyspace offers a quiet, contemplative space for the campus community and visitors.

In naming *The Color Inside*, Turrell said, "I was thinking about what you see inside, and inside the sky, and what the sky holds within it that we don't see the possibility of in our regular life." The space he created encourages the kind of quiet reflection that cultivates attention. Turrell reminds us that not only does light reveal what is around us, it also makes known that which is within us.

The Color Inside, 2013
Black basalt, plaster, and LED lights
224 × 348 × 276 inches

Commission, Landmarks, The University of
Texas at Austin, 2013

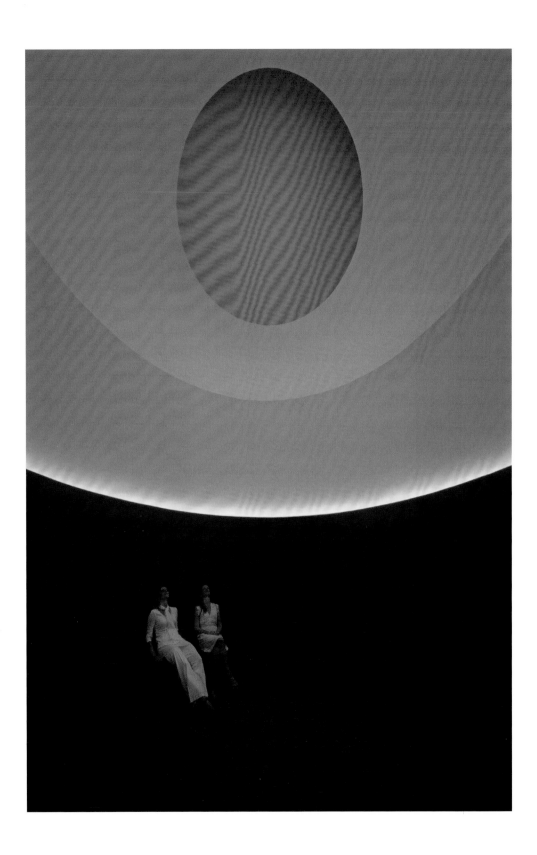

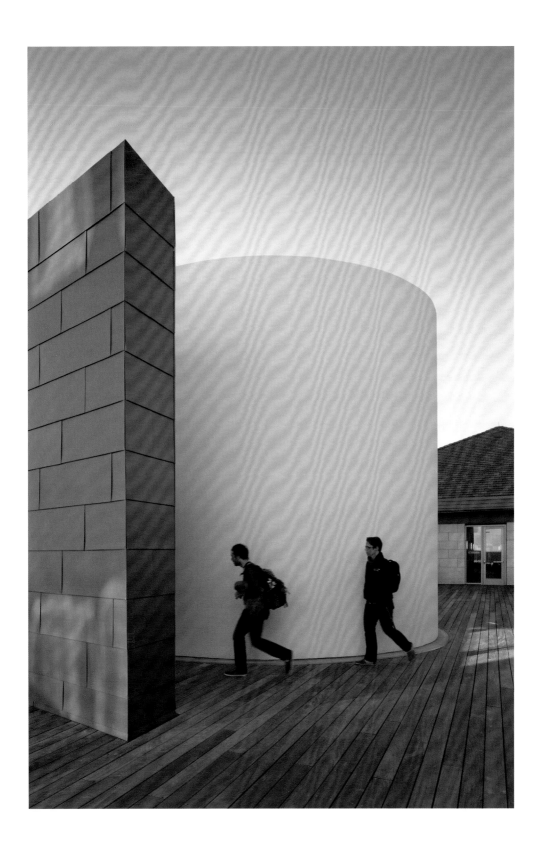

URSULA VON RYDINGSVARD

AMERICAN, BORN IN GERMANY, 1942

The daughter of a Ukrainian peasant woodcutter who fled to Germany in 1938, Ursula von Rydingsvard spent the first eight years of her life in a succession of refugee camps until 1950, when her family settled in Plainville, Connecticut. Determined to pursue a career as an artist, she studied painting at the University of Miami and the University of California, Berkeley, and received her MFA at Columbia University in 1975.

When she arrived in New York in 1973, minimalism was at its height. Although von Rydingsvard admired the logic and clarity of the movement, she needed a more expressive and tactile connection to her art. Thus, she joined the new generation of sculptors loosely labeled "postminimalist," and conceived her compositions as structural repetitions or sequences of basic forms, sculpting them in an intuitive and organic way.

Von Rydingsvard works primarily in cedar, using chain saws, circular saws, traditional hand chisels, and a mallet to sculpt her pieces. She constructs her sculptures from ordinary four-by-four-inch beams, carving and chipping the wood into organic forms with craggy surfaces, and then rubbing the surfaces of some works with powdered graphite. The dark gray graphite on reddish brown cedar produces a nuanced surface coloration that suggests the patina of time.

Von Rydingsvard's penchant for carving in wood derives from her Polish-Ukrainian roots; her ancestors were peasant farmers whose survival depended on wood for tools and shelter. In her formative years, the material surrounded her in German refugee camps. "It's somewhere in my blood.… Working with it and looking at it feels familiar."

Untitled has the subtitle *Seven Mountains*, perhaps an allusion to the fact that von Rydingsvard was one of seven children. The layers of wood resemble the stone striations of geological formations, like those visible in desert canyons or archaeological excavations. With every cut and gouge made prominent, her sculptures demonstrate the highly physical, expressive act of sculpting.

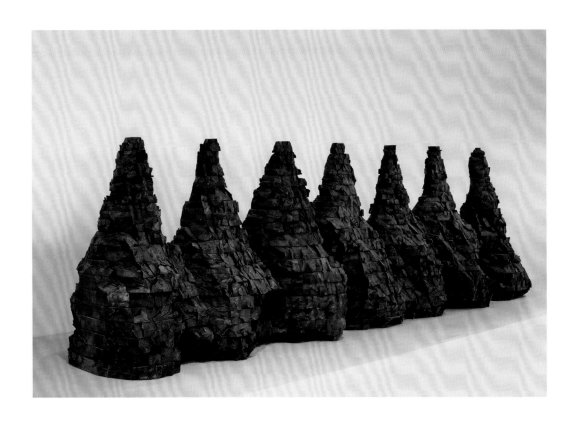

Untitled (Seven Mountains), 1986–1988
Cedar and graphite powder
62 × 201 × 42 inches

Lent by The Metropolitan Museum of Art
Purchase, Lila Acheson Wallace Gift, 1988
1988.257a–u

ANITA WESCHLER

AMERICAN, 1914–2001

Anita Weschler worked in modes ranging from portraiture to abstraction using a variety of materials such as paint, stone, wood, and bronze. A cofounder of the Sculptors' Guild in New York, she strove to create works that balance "form and substance." According to Weschler, "Each is determined by the other and each is dependent on the other. The finer an art is the closer it approaches the point where fusions of mind and matter are complete and perfect."

In her work Weschler united the simplification of forms practiced by primitivists and championed by her mentor, William Zorach (1887–1966), with challenging, poignant themes confronted by early-twentieth-century pacifists like German expressionist sculptor Ernest Barlach (1870–1938). Zorach, one of the leading proponents of direct carving, valued the intrinsic connection between sculptor and material. Though Weschler preferred casting to direct carving, she was drawn to the natural texture of stone. In her search for an alternative to bronze casting, she developed her own method of stone casting in which aggregate cements and crushed stone are poured into a mold.

During the late 1930s and early 1940s, Weschler made a series of sculptures that explore antiwar themes, all of which she executed with bold forms and strong contours. *Victory Ball* concludes the series with an image of people celebrating the end of World War II. Although ostensibly an expression of joy, the dense, multifigure composition shows the bacchanalian excesses of street celebrations in 1945. Inebriated male figures collapse in a pile, while a lone woman on the right dances with abandon. Attuned to the increasingly consumerist ethos of American society in the early 1950s, Weschler looked back on the 1945 celebrations as harbingers of future excess.

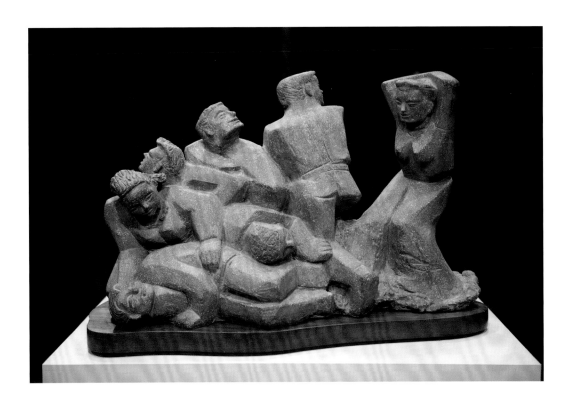

Victory Ball, 1951
Cast stone
24 × 41 × 23 ½ inches

Lent by The Metropolitan Museum of Art
Purchase, Morris and Rose Rochman Gift, 1982
1982.43

LANDMARKS VIDEO

Landmarks Video presents some of the most highly regarded and influential works of video art from the past five decades. The program familiarizes audiences with important titles, stimulates conversation and research, and situates the genre of video art alongside the presentation of more traditional works. Featuring a new artist each month, Landmarks Video can be viewed on a media station in the ART building atrium. An original essay about each artist and their work is available at **landmarks.utexas.edu**.

MARINA ABRAMOVIĆ and CHARLES ATLAS
SERBIAN, BORN 1946; AMERICAN, BORN 1949

SSS, 1989
Video, 06:00 min., color, sound

Courtesy of Electronic Arts Intermix (EAI), New York
Exhibited May 2016

VITO ACCONCI AMERICAN, 1940–2017

Theme Song, 1973
Video, 33:15 min., b&w, sound

Courtesy Electronic Arts Intermix (EAI), New York
Exhibited January 2013

TERRY ADKINS AMERICAN, 1953–2014

Synapse, 2004
Video, 18:01 min., color, sound

Courtesy of the Estate of Terry Adkins and Salon 94, New York
Exhibited September 2015

AES+F FORMED IN 1987

Inverso Mundus, 2015
HD Video, 38:20 min., color, sound

Courtesy of the artists, Multimedia Art Museum Moscow, and Mobius Gallery
Exhibited November 2017

MAX ALMY AMERICAN, BORN 1948

Leaving the 20th Century, 1982
Video, 11:00 min., color, sound

Courtesy of the Video Data Bank at the School of the Art
Institute of Chicago, www.vdb.org
Exhibited March 2018

LAURIE ANDERSON AMERICAN, BORN 1947

What You Mean We?, 1986
Video, 20 min., color, sound

Courtesy of the Video Data Bank at the School of the Art
Institute of Chicago, www.vdb.org
Exhibited June 2011

ELEANOR ANTIN AMERICAN, BORN 1935

The Little Match Girl Ballet, 1975
Video, 26:30 min., color, sound

Courtesy Electronic Arts Intermix (EAI), New York
Exhibited by December 2014

JOHN BALDESSARI AMERICAN, BORN 1931

I Will Not Make Any More Boring Art, 1971
Video, 32:21 min., b&w, mono

Image copyright of the artist, courtesy of the Video
Data Bank at the School of the Art Institute of Chicago,
www.vdb.org
Exhibited June 2016

BURT BARR AMERICAN, 1938–2016

The Elevator, 1985
Video, 05:10 min., color, sound

Courtesy Electronic Arts Intermix (EAI), New York
Exhibited May 2015

LYNDA BENGLIS AMERICAN, BORN 1941

Now, 1973
Video, 12:00 min., color, sound

Courtesy Electronic Arts Intermix (EAI), New York
Exhibited September 2012

SADIE BENNING AMERICAN, BORN 1973

Girl Power, 1993
Video, 15:00 min., b&w, sound

Courtesy of the Video Data Bank at the School of the Art
Institute of Chicago, www.vdb.org
Exhibited June 2018

DARA BIRNBAUM AMERICAN, BORN 1946

Technology/Transformation: Wonder Woman,
1978–1979
Video, 5:50 min., color, sound

Courtesy Electronic Arts Intermix (EAI), New York
Exhibited March 2012

JAY BOLOTIN AMERICAN, BORN 1949

The Jackleg Testament Part I:
The Story of Jack & Eve, 2007
Woodcut motion picture, 62:00 min.,
color, sound

Courtesy of the artist
Exhibited November 2014

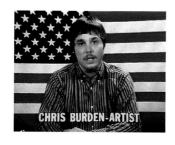

CHRIS BURDEN AMERICAN, 1946–2015

The TV Commercials, 1973–1977/2000
Video, 03:46 min., color, sound

Courtesy Electronic Arts Intermix (EAI), New York
Exhibited June 2015

SOPHIE CALLE and GREGORY SHEPHARD
FRENCH, BORN 1953; AMERICAN, DATES UNKNOWN

Double-Blind, 1992
Video, 75:58 min., color, sound

Courtesy Electronic Arts Intermix (EAI), New York
Exhibited August 2013

THERESA HAK KYUNG CHA
KOREAN-BORN AMERICAN, 1951-1982

Re Dis Appearing, 1977
Video, 02:30 min., b&w, sound

Courtesy of Electronic Arts Intermix (EAI), New York
Collection UC Berkeley Art Museum and Pacific Film Archive
Exhibited August 2017

PATTY CHANG AMERICAN, BORN 1972

Contortion, 2000
Video, 02:20 min., color, silent

Courtesy of the artist
Exhibited May 2014

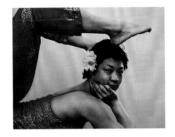

MERCE CUNNINGHAM and RICHARD MOORE
AMERICAN, 1919-2009; AMERICAN, 1920-2015

Assemblage, 1968
16mm film on video, 58:03 min., color, sound

Courtesy of Electronic Arts Intermix (EAI), New York
Exhibited December 2015

ALEX DA CORTE AMERICAN, BORN 1980

Chelsea Hotel no. 2, 2010
HD digital video, 03:04 min., color, sound

Courtesy of the artist
Exhibited September 2016

CHERYL DONEGAN AMERICAN, BORN 1962

Artists + Models, 1998
Video, 04:43 min., b&w, sound

Courtesy of Electronic Arts Intermix (EAI), New York
Exhibited May 2017

VALIE EXPORT AUSTRIAN, BORN 1940

Touch Cinema, 1968
16mm film on video, 01:18 min., b&w, sound

Courtesy Electronic Arts Intermix (EAI), New York
Exhibited July 2014

CAO FEI CHINESE, BORN 1978

Shadow Life, 2011
Video, 10:00 min., b&w, sound

Courtesy of Cao Fei and Vitamin Creative Space
Exhibited February 2016

JESSE FLEMING AMERICAN, BORN 1977

The Snail and the Razor, 2012
Single-channel video, 07:56 min., color, sound

Courtesy Electronic Arts Intermix (EAI), New York
Exhibited October 2012

SYLVIE FLEURY SWISS, BORN 1961

Walking on Carl Andre, 1997
Video, 24:40 min., color, sound

Courtesy of the artist and Salon 94, New York
Exhibited March 2015

HERMINE FREED AMERICAN, 1940–1998

Art Herstory, 1974
Video, 22:00 min., color, sound

Courtesy of the Video Data Bank at the School of the Art
Institute of Chicago, www.vdb.org
Exhibited December 2017

COCO FUSCO and PAULA HEREDIA
AMERICAN, BORN 1960; SALVADORAN, BORN 1955

Couple in the Cage: Guatianaui Odyssey, 1993
Video, 31:00 min., b&w and color, sound

Image copyright of the artist, courtesy of the Video Data Bank
at the School of the Art Institute of Chicago, www.vdb.org
Exhibited October 2015

KATE GILMORE AMERICAN, BORN 1975

Buster, 2011
Video, 10 min., color, sound

Courtesy David Castillo Gallery, Miami Beach
Exhibited February 2013

LUIS GISPERT AMERICAN, BORN 1972

Block Watching, 2003
Digital video, 01:57 min., color, sound

Courtesy of artist and OHWOW Gallery, Los Angeles
Exhibited March 2016

DOUGLAS GORDON SCOTTISH, BORN 1966

Domestic, 2002
Video, 13:58 min., color, silent

Courtesy of the artist and Gagosian Gallery, New York
© 2016 Studio lost but found / Artists Rights Society
(ARS), New York / VG Bild-Kunst, Bonn
Exhibited January 2017

ROKNI HAERIZADEH IRANIAN, BORN 1978

Reign of Winter, 2012–2013
Video, 06:00 min., color, silent

Courtesy of the artist and
Gallery Isabelle van den Eynde, Dubai
Exhibited September 2014

ANN HAMILTON AMERICAN, BORN 1956

(abc · video), 1994/1999
Video, 30:00 min., b&w, silent

Courtesy of Ann Hamilton Studio
Exhibited February 2017

MONA HATOUM
BRITISH, BORN 1952 IN LEBANON OF PALESTINIAN DESCENT

Measures of Distance, 1988
Video, 15:30 min., color, sound

Image copyright the artist, courtesy of the Video Data Bank at the
School of the Art Institute of Chicago, www.vdb.org
Exhibited July 2015

GARY HILL AMERICAN, BORN 1951

Around & About, 1980
Video, 05:00 min., color, sound

Courtesy Electronic Arts Intermix (EAI), New York
Exhibited August 2015

JENNY HOLZER AMERICAN, BORN 1946

Televised Texts, 1990
Video, 13:00 min., color, sound

Courtesy of the Video Data Bank at the School of the Art
Institute of Chicago, www.vdb.org
Exhibited April 2012

JOAN JONAS AMERICAN, BORN 1936

Vertical Roll, 1972
Video, 19:38 min., b&w, sound

Courtesy Electronic Arts Intermix (EAI), New York
Exhibited August 2011

MIRANDA JULY AMERICAN, BORN 1974

The Amateurist, 1998
Video, 14:00 min., color, sound

Image copyright the artist, courtesy of the Video Data Bank
at the School of the Art Institute of Chicago, www.vdb.org
Exhibited January 2014

MIKE KELLEY AMERICAN, 1954–2012

The Banana Man, 1983
Video, 28:15 min., color, sound

Courtesy Electronic Arts Intermix (EAI), New York
Exhibited January 2012

WILLIAM KENTRIDGE
SOUTH AFRICAN, BORN 1955

Felix in Exile, 1994
35mm film transferred to DVD, 8:43 min.,
color, sound

Courtesy the artist and Marian Goodman Gallery, New York
Exhibited March 2011

JULIA KUL POLISH, BORN 1983

Passport Reading, 2011
Single-channel video, 08:44 min., color, sound

Courtesy Postmasters Gallery, New York
Exhibited April 2013

SIGALIT LANDAU ISRAELI, BORN 1969

DeadSee, 2005
Video, 11:39 min., color, silent

Courtesy the artist and kamel mennour, Paris
Exhibited February 2012

MARK LEWIS CANADIAN, BORN 1957

The Fight, 2008
High Definition, 5:27 min., color, silent

Courtesy and copyright the artist and
Monte Clark Gallery, Vancouver
Exhibited April 2011

KALUP LINZY AMERICAN, BORN 1977

*Conversations Wit de Churen V: As da Art World
Might Turn*, 2006
Video, 12:10 min., color, sound

Courtesy Electronic Arts Intermix (EAI), New York
Exhibited July 2013

GORDON MATTA-CLARK AMERICAN, 1943–1978

Splitting, 1974
Super 8mm film on video, 10:50 min.,
b&w and color, silent

Courtesy Electronic Arts Intermix (EAI), New York
Exhibited November 2013

EVA and FRANCO MATTES ITALIANS, BORN 1976

Emily's Video, 2012
Video, 15:52 min., color, sound

Courtesy of Postmasters Gallery, New York
Exhibited October 2013

JOSEPHINE MECKSEPER GERMAN, BORN 1964

0% Down, 2008
Video transferred to DVD, 6 min., b&w, sound

Courtesy of Elizabeth Dee Gallery, New York
Exhibited October 2011

ANA MENDIETA
AMERICAN, BORN IN CUBA, 1948–1985

Untitled (Blood Sign #2/Body Tracks), 1974
Super-8mm film transferred to DVD, 1:01 min.,
color, silent

Courtesy Galerie Lelong, New York
Exhibited August 2014

MARILYN MINTER AMERICAN, BORN 1948

Green Pink Caviar, 2009
HD digital video, 07:45 min., color, sound

Courtesy of the artist and Salon 94, New York
Exhibited April 2017

KENT MONKMAN
CANADIAN OF CREE ANCESTRY, BORN 1965

Group of Seven Inches, 2005
Video, 07:35 min., b&w, sound

Courtesy of Vtape.org
Exhibited December 2016

LINDA MONTANO AMERICAN, BORN 1942

Mitchell's Death, 1977
Video, 22:20 min., b&w, sound

Image copyright the artist, courtesy of the Video Data
Bank at the School of the Art Institute of Chicago,
www.vdb.org
Exhibited January 2015

SARAH MORRIS BRITISH, BORN 1967

Beijing, 2008
35mm/HD, 84:47 min., color, sound

© Sarah Morris. Courtesy White Cube
Exhibited January 2018

RITA MYERS AMERICAN, BORN 1947

Tilt 1, 1973
Video, 06:50 min., b&w, sound

Courtesy of Electronic Arts Intermix (EAI), New York
Exhibited June 2017

BRUCE NAUMAN AMERICAN, BORN 1941

Walk with Contrapposto, 1968
Video, 60 min., b&w, sound

Courtesy Electronic Arts Intermix (EAI), New York
© 2010 Bruce Nauman/Artist Rights Society (ARS), New York
Exhibited May 2011

TAMEKA JENEAN NORRIS
AMERICAN, BORN 1979 IN GUAM

Untitled (Say Her Name), 2011-2015
Video, 04:47 min., color, sound

Courtesy of the artist and Jane Lombard Gallery, New York
Exhibited November 2016

TONY OURSLER AMERICAN, BORN 1957

The Weak Bullet, 1980
Video, 12:41 min., color, sound

Courtesy Electronic Arts Intermix (EAI), New York
Exhibited December 2010

NAM JUNE PAIK and JOHN GODFREY
KOREAN, 1932–2006; AMERICAN, BORN 1943

Global Groove, 1973
Video, 28:30 min., color, sound

Courtesy Electronic Arts Intermix (EAI), New York
Exhibited November 2011

CHARLEMAGNE PALESTINE
AMERICAN, BORN 1947

Body Music I/Body Music II, 1973–1974
Video, 20:30 min., b&w, sound

Courtesy Electronic Arts Intermix (EAI), New York
Exhibited August 2018

ALIX PEARLSTEIN AMERICAN, BORN 1962

Goldrush, 2008
HD video, 03:05 min., color, sound

Courtesy Electronic Arts Intermix (EAI), New York
Exhibited June 2014

JOHN PILSON AMERICAN, BORN 1968

Mr. Pick Up, 2001
Three-channel video, 17:00 min., color, sound

Courtesy Nicole Klagsbrun Gallery, New York
Exhibited May 2012 & August 2012

CHERYL POPE AMERICAN, BORN 1980

Up Against, 2010
Single-channel HD video, 10:00 min., color, sound

Courtesy of the artist and Mark Moore Gallery, Culver City
Exhibited September 2013

NICOLAS PROVOST BELGIAN, BORN 1969

Papillon d'amour, 2003
Video, 04:00 min., b&w, sound

Image copyright the artist, courtesy of the Video Data Bank,
www.vdb.org
Exhibited April 2014

YVONNE RAINER AMERICAN, BORN 1934

After Many a Summer Dies the Swan, 2002
Video, 31 min., color, sound

Courtesy of the Video Data Bank at the School of the Art
Institute of Chicago, www.vdb.org
Exhibited January 2011

MIGUEL ANGEL RÍOS ARGENTINIAN, BORN 1943

Crudo, 2008
Video, 03:14 min., color, sound

Courtesy of the artist and Sicardi Gallery, Houston, TX
Exhibited October 2016

PIPILOTTI RIST SWISS, BORN 1962

I'm a Victim of This Song, 1995
Video, 5:06 min., color, sound

Courtesy Electronic Arts Intermix (EAI), New York
Exhibited September 2011

MIGUEL ÁNGEL ROJAS COLOMBIAN, BORN 1946

Corte en el ojo, 2003
Video, 06:47 min., color, sound

Courtesy of Sicardi Gallery, Houston, TX
Exhibited October 2014

MARTHA ROSLER AMERICAN, BORN 1943

Semiotics of the Kitchen, 1975
Video, 6:09 min, b&w, sound

Courtesy Electronic Arts Intermix (EAI), New York
Exhibited June 2013

TOM RUBNITZ and ANN MAGNUSON
AMERICAN, 1956–1992; AMERICAN, BORN 1956

Made for TV, 1984
U-matic video, 15:00 min., color, sound

Image copyright of the artist, courtesy of the Video Data Bank
at the School of the Art Institute of Chicago, www.vdb.org
Exhibited January 2016

CHEN SAI HUA KUAN
SINGAPOREAN, BORN 1976

Space Drawing No. 7, 2010
Digital film, 60 sec., color, sound

Courtesy of the artist and Osage Gallery, Hong Kong
Exhibited February 2015

ZINA SARO-WIWA NIGERIAN, BORN 1976

Table Manners, 2014–2016
Video, 61:22 min., color, sound

Courtesy of the artist and Tiwani Contemporary, London
Exhibited April 2018

MARKUS SCHINWALD AUSTRIAN, BORN 1973

Orient, 2011
Looped, two-channel HD video, 09:00 min. each,
color, sound

Courtesy the artist and Yvon Lambert Gallery, Paris
Exhibited March 2013

CAROLEE SCHNEEMANN AMERICAN, BORN 1939

Viet Flakes, 1965
Film on video, 7 min., toned b&w, sound

Courtesy Electronic Arts Intermix (EAI), New York
© Carolee Schneemann/Artist Rights Society (ARS), New York
Exhibited July 2011

RICHARD SERRA AMERICAN, BORN 1939

Hand Catching Lead, 1968
16mm film transferred to DVD, 3:02 min., b&w, silent

Courtesy Museum of Modern Art, New York
© 2010 Richard Serra/Artist Rights Society (ARS), New York
Exhibited February 2011

TERESA SERRANO MEXICAN, BORN 1936

La piñata, 2003
Video, 05:45 min., color, sound

Courtesy of the artist and EDS GALERIA, Mexico City
Exhibited October 2017

YINKA SHONIBARE MBE BRITISH, BORN 1962

Un ballo in maschera (A Masked Ball), 2004
HD Video, 32:00 min., color, sound

Courtesy of the artist and James Cohan Gallery
Exhibited September 2017

LORNA SIMPSON AMERICAN, BORN 1960

Corridor, 2003
Double-projection video installation; video
transferred to DVD, 13:45 min., color, sound

Courtesy of Salon 94
Exhibited December 2013

ROBERT SMITHSON AMERICAN, 1938–1973

Spiral Jetty, 1970
16mm film on video, 35:00 min., color, sound

Courtesy Electronic Arts Intermix (EAI), New York
Art © Estate of Robert Smithson/Licensed by VAGA, New York, NY
Exhibited May 2013

JOE SOLA AMERICAN, BORN 1966

Studio Visit, 2005
Digital video, 08:00 min., color, sound

Courtesy of Blackston, New York and Tif Sigfrids,
Los Angeles
Exhibited November 2015

RYAN TRECARTIN AMERICAN, BORN 1981

Sibling Topics (section a), 2009
HD video, 50:00 min., color, sound

Courtesy of Electronic Arts Intermix (EAI), New York
Exhibited July 2016

RACHEL PERRY WELTY
AMERICAN, BORN 1962 IN TOKYO, JAPAN

Karaoke Wrong Number, 2001–2004 and 2005–2009
Video on DVD, 07:14 and 05:46 min., color, sound

Courtesy of the artist and Yancey Richardson Gallery,
New York
Exhibited March 2014

KEHINDE WILEY AMERICAN, BORN 1977

Smile, 2003
Digital video, 90:00 min., color, sound

Courtesy of the artist and Roberts & Tilton Gallery,
Los Angeles
Exhibited March 2017

HANNAH WILKE AMERICAN, 1940–1993

Gestures, 1974
Video, 35:30 min., b&w, sound

Courtesy of Electronic Arts Intermix (EAI), New York
Exhibited April 2016

DAVID WOJNAROWICZ AMERICAN, 1954–1992

A Fire in My Belly (A Work in Progress), 1986–1987
Super 8mm film on video, 20:55 min., color and b&w, silent

Courtesy Electronic Arts Intermix (EAI), New York
Exhibited May 2018

BRUCE and NORMAN YONEMOTO
AMERICAN, BORN 1949 AND 1946

Vault, 1984
Video, 11:45 min., color, sound

Courtesy Electronic Arts Intermix (EAI), New York
Exhibited November 2012

HÉCTOR ZAMORA MEXICAN, BORN 1974

O abuso da história (The Abuse of History), 2014
Video, 01:52 min., color, sound

Courtesy of the artist and Luciana Brito Galeria, São Paulo, Brazil
Exhibited February 2018

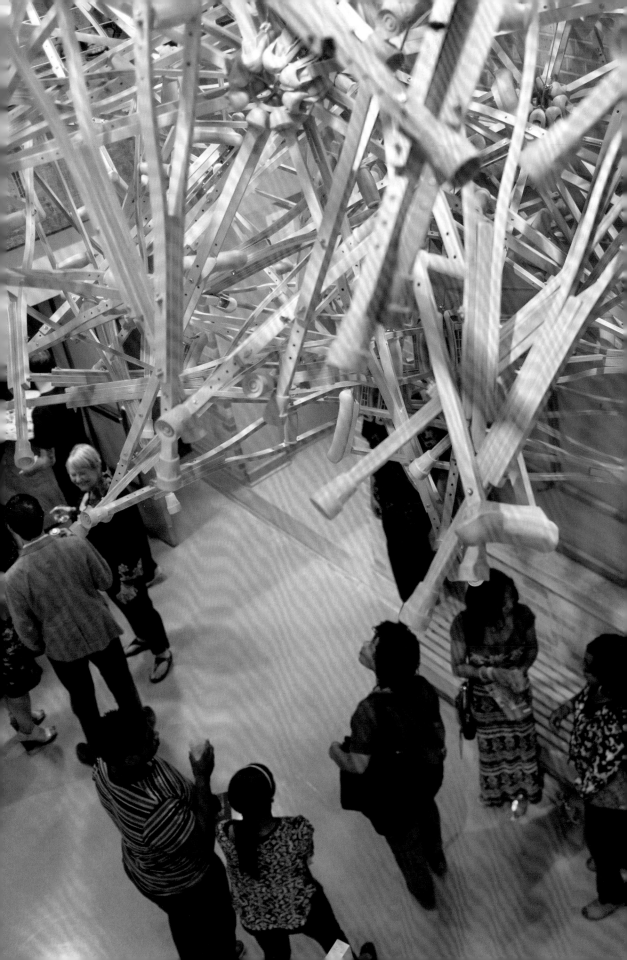

PROGRAMS

Beyond visiting the main campus and spending time with the Landmarks collection, there are many ways for curious minds to learn more about the works of public art on display and the artists who created them. Visit landmarks.utexas.edu for information about the collection, special events, and ways to support public art on campus.

VISIT
Landmarks projects are concentrated on the main campus. Public art located outdoors is available for viewing at all times, whereas works located indoors may be viewed when each building is open. To make a free reservation to visit the James Turrell Skyspace, *The Color Inside*, visit turrell.utexas.edu.

TOURS
Experience public art on campus by taking a free, docent-led walking tour or bike tour. They are a fun and informative way to learn about works of art in the collection while enjoying the beauty of the main campus. Visitors are encouraged to participate in regularly scheduled public tours, or to schedule a free docent-led tour.

SPECIAL EVENTS
Attend opening receptions, artists' talks, performances, and lectures focused on public art in the Landmarks collection. Check the website for information about upcoming special events and join the mailing list for notices.

AUDIO GUIDES
Stream free audio guides featuring works in the collection on the Landmarks website. Visitors may use mobile devices to listen to the guides while viewing the works of art on display.

PUBLIC ART CAMPUS MAPS
Take a self-guided tour using a public art campus map or a mobile device. Maps can be found at the Visitor Center and at many cultural institutions and libraries on campus.

ACTIVITY GUIDES
Engage younger minds with activity guides designed for three developmental stages: younger children, older children, and adolescents. Guides offer an overview of each work of art, questions to consider when viewing, activities that demonstrate relevant themes, and a list of key vocabulary.

LANDMARKS PRESERVATION GUILD

The Landmarks Preservation Guild maintains the works of art in the collection. Volunteers learn to apply basic conservation skills and devote time and energy to preserve works of public art so they may be enjoyed by future generations.

LANDMARKS DOCENTS

Landmarks Docents share their expertise by introducing the campus community and visitors to the public art collection. Volunteers offer insight into the artists and their work, build awareness about modern and contemporary art, and create enriching experiences for participants.

RESOURCES

Read artist essays and search bibliographic highlights for each work of art on the Landmarks website. Many of the primary references listed on the site may be found at the Fine Arts Library on campus.

SUPPORT LANDMARKS

To support public art conservation and education at the university, please visit **landmarksdonate.org** or call 512.495.4315.

THANKS

Landmarks thanks the following contributors for their outstanding support and for believing that great art can elevate communities when it is free and accessible to all.

DONORS

James C. Armstrong and O. Lawrence Connelly
Suzanne Deal Booth
Leslie and Brad Bucher
Jereann Chaney
Paula and Daniel Daly
Susan and Michael Dell
GalleryLOG
Jeanne and Michael Klein
Petie and Bryan Lewis
lookthinkmake
Kathleen Irvin Loughlin and Christopher J. Loughlin
Charlene and Tom Marsh
Chris L. Mattsson
Fredericka and David Middleton
James A. Miller
Leila and Walter Mischer
National Endowment for the Arts
Phillips Nazro and Neal Thomas
Diane and Charles Ofner
Lora Reynolds and Quincy Lee
Still Water Foundation
The Tapeats Fund
Texas Commission on the Arts
Tocker Foundation
Emily Hall Tremaine Foundation (EHTF)
Miriam Ward
Jill and Stephen Wilkinson

LEADERSHIP

Darrell Bazzell and Financial and Administrative Services
Andrée Bober and Landmarks
Michael Carmagnola and Project Management and Construction Services
Douglas Dempster and the College of Fine Arts
Gregory Fenves and the Office of the President
David Rea and the Office of Campus Planning and Facilities Management
James Shackelford and Capital Planning and Construction
Michelle Addington and the Campus Master Planning Committee

LANDMARKS ADVISORY COMMITTEE
Francesca Balboni, 2017–present
Mirka Benes, 2008–2010
Sarah Canright, 2008–2010
Annette Carlozzi, 2008–2013
Eddie Chambers, 2012–2013
John Clarke, 2008–2011
Amanda Douberly, 2008–2009
George Flaherty, 2017–present
Lauren Hanson, 2009–2012
Amy Hauft, 2013–present
Juan Miró, 2010–2016
Ann Reynolds, 2011–2017
Veronica Roberts, 2013–present
Igor Siddiqui, 2018–present
Michael Smith, 2010–2017
Jason Sowell, 2016-2017
John Stoney, 2017–present
Robin Williams, 2012–2017

STAFF
Nisa Barger, Assistant Director for Collections
Andrée Bober, Founder and Director
Deb Duval, Event Coordinator
Kanitra Fletcher, Landmarks Video Curator
Bill Haddad, Technology Manager
Kristi Johnson, Administrative Assistant
Emma Kirks, Assistant Director for Operations
Emmy Laursen, Communications Coordinator
Maggie Mitts, Collections Assistant
Stephanie Taparauskas, Assistant Director for Development
Jennalie Travis, Development Officer
Catherine Zinser, Education Coordinator

COMMUNITY PARTNERS
American Institute of Architects, Austin
Art Alliance Austin
Austin Museum Partnership
Blanton Museum of Art
Blue Dog Rescue
City of Austin Art in Public Places
Flatbed Press
Fusebox Festival
Harry Ransom Center
Orange Bike Project
Texas Performing Arts
The Contemporary Austin
UMLAUF Sculpture Garden
Visual Arts Center

PHOTOGRAPHY CREDITS

Ben Aqua: 59, 133
Dror Baldinger: 25, 55, 69, 75, 77, 79, 83, 93, 95, 100
Paul Bardagjy: 4/5, 13, 14/15, 17, 27, 28, 29, 31, 35,
 36/37, 39, 47, 52, 87, 90/91, 97, 99, 101, 103, 104, 105,
 107, 109, 110/111, 113, 114/115, 117, 118, 119, 120/121, 127,
 128, 129, 134/135, 166/167
Sandy Carson: 66 (lower), 67 (upper), 71, 158
Ann Hamilton: 164
Serena Hayden: 125
Florian Holzherr: 6, 126
Mark Menjivar: 19, 33, 57, 61, 63, 65, 66 (upper),
 67 (lower), 81, 85, 131
The Metropolitan Museum of Art: 21, 23
Marsha Miller: 2/3, 73
Christina Murrey: 8/9, 10, 41 (upper left, lower left,
 middle right; remainder are film stills from *Animal*),
 42/43, 123, 136, 155, 156/157, 160, 161
Rey Parlá: 88/89
Catherine Zinser: 70

Cover image: José Parlá, detail of study for
 Amistad América, 2018
Inside cover: Ann Hamilton, detail of
 O N E E V E R Y O N E · Ann, 2017